C000218220

OXFORD

OXFORD
MARTIN PARR

With an afterword by
Simon Winchester

Bodleian Libraries
UNIVERSITY OF OXFORD

OXFORD
UNIVERSITY PRESS

MICHAELMAS TERM

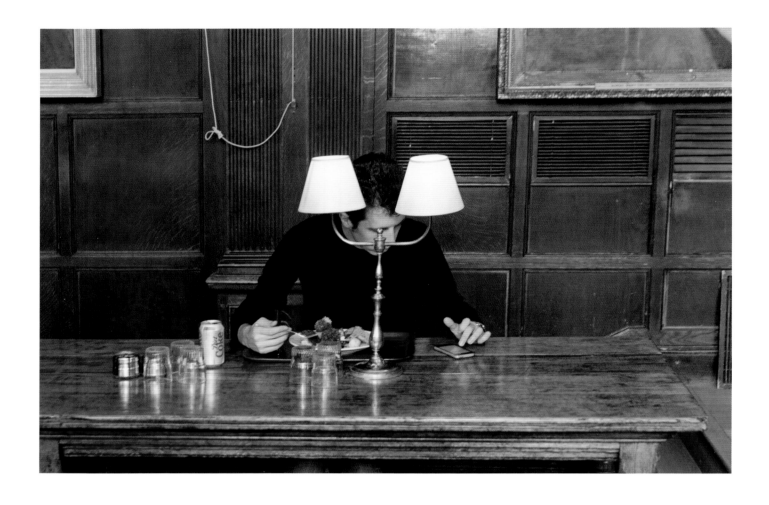

Balliol College dining hall.

Frontispiece Balliol College.

Senior Common Room, Balliol College.

Tutorial by Dr Sudhir Hazareesingh, Balliol College.

Junior Common Room, Regent's Park College.

All colleges maintain very active programmes for their alumni.
Perhaps the oldest group is the class of 1955 at St Hilda's who
meet every year during the university's Alumni Weekend in
September. Back in 1955 St Hilda's was all female and was
the last woman's college to accept men—in 2008.

'Old Hands, New Faces', Wolfson College. Nearly all colleges
put on an event at the end of Freshers' Week, where new students
can meet established students and find a mentor to help them
through their new college life.

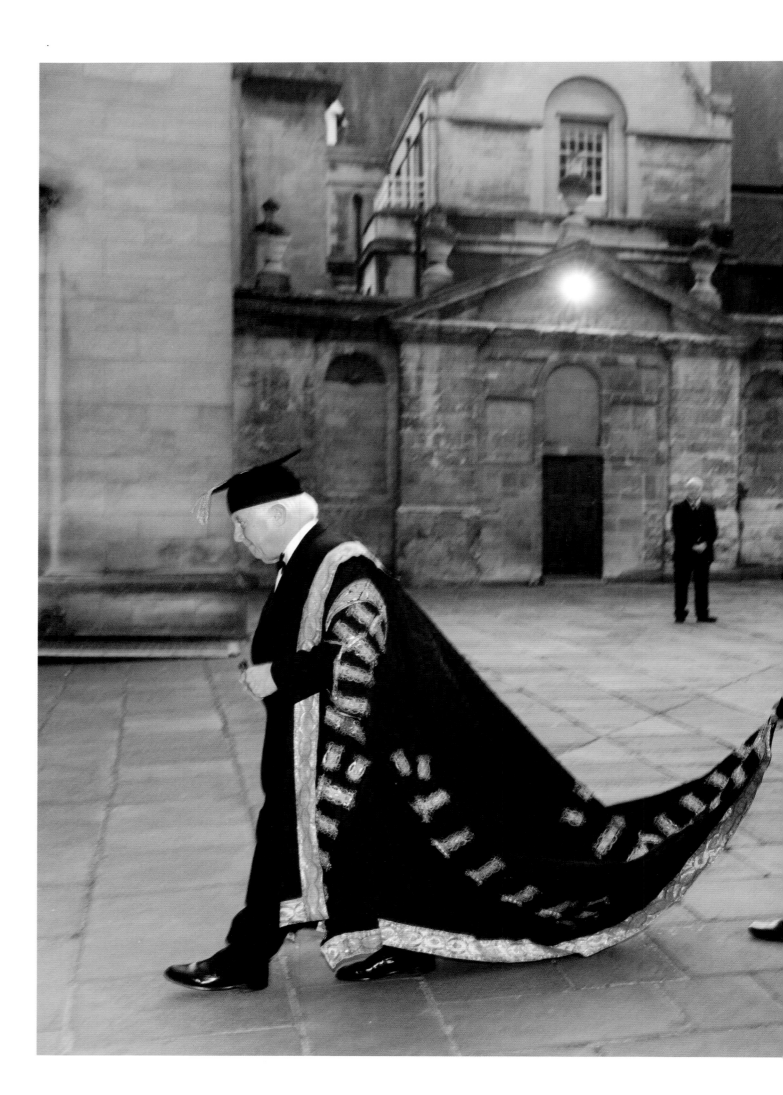

Vice-Chancellor's Oration. At the beginning of each academic year the vice-chancellor gives a speech in Convocation House.

Previous page Chancellor Lord Patten of Barnes with his page. Traditionally the role of page would be filled by his grandson, but this is not the case with the current page, Giles Wordsworth, who has done this for five years. He holds the chancellor's long gown at formal events.

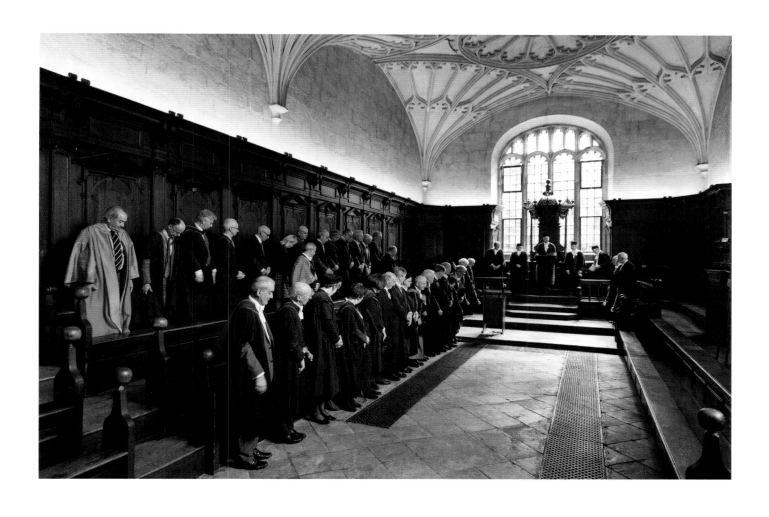

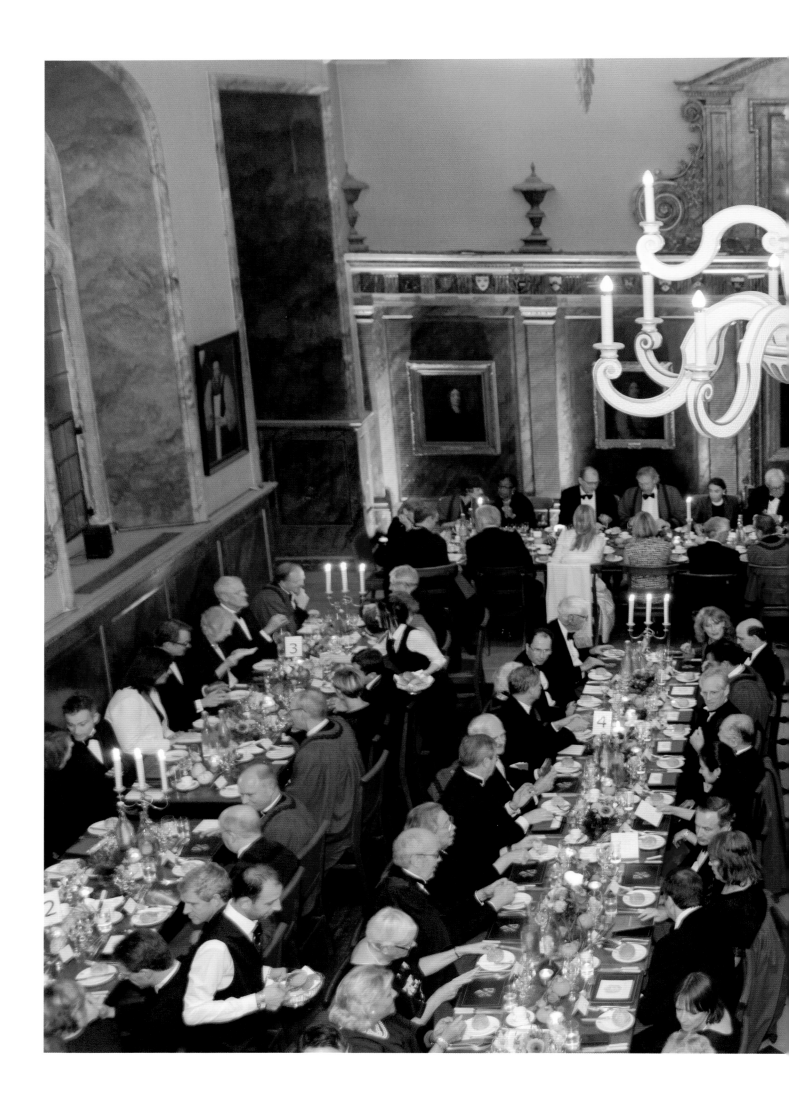

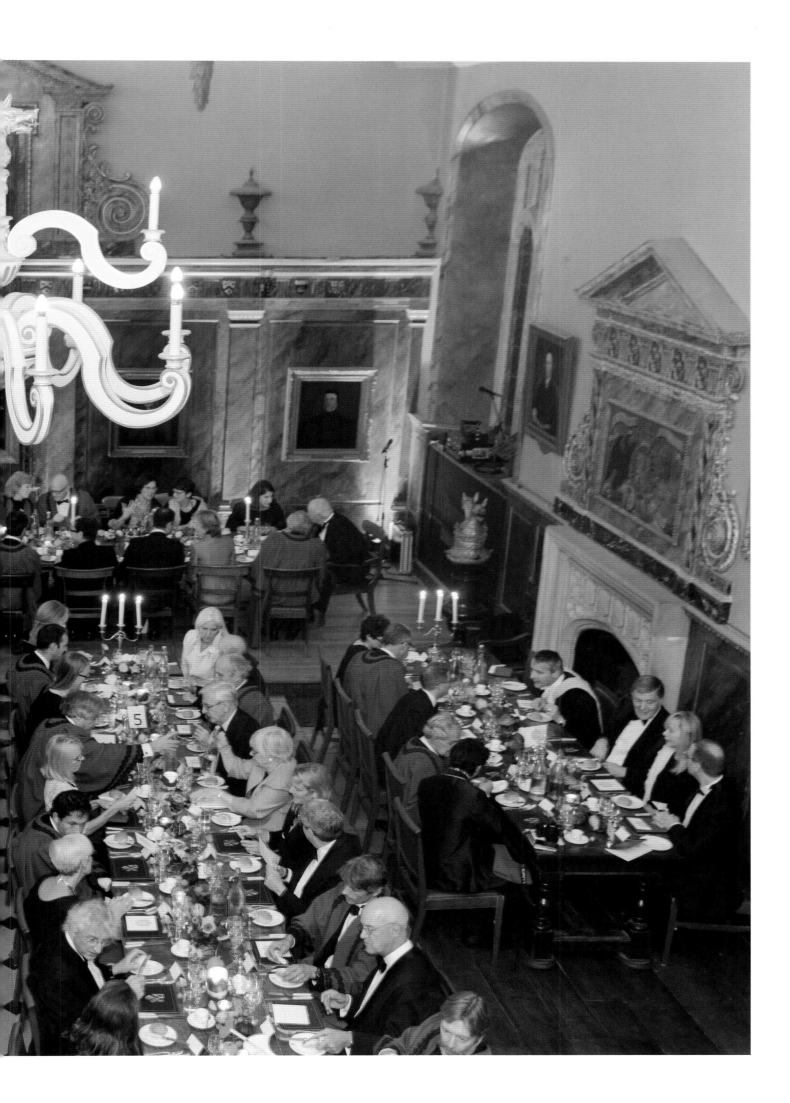

Freshers' Fair, Examinations School.

Previous page The annual meeting of the Chancellor's Court of Benefactors. Only individuals or organizations who donate more than £1.5 million are eligible to become members of the court, who are admitted in a special ceremony, presided over by the chancellor.

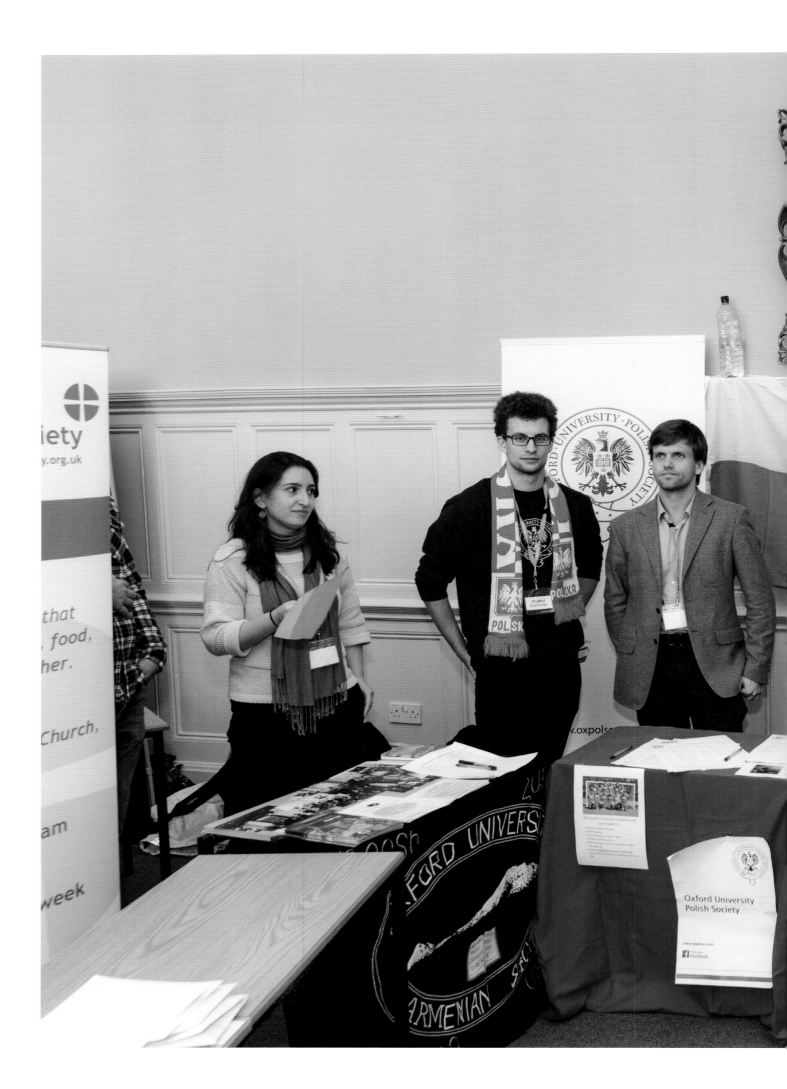

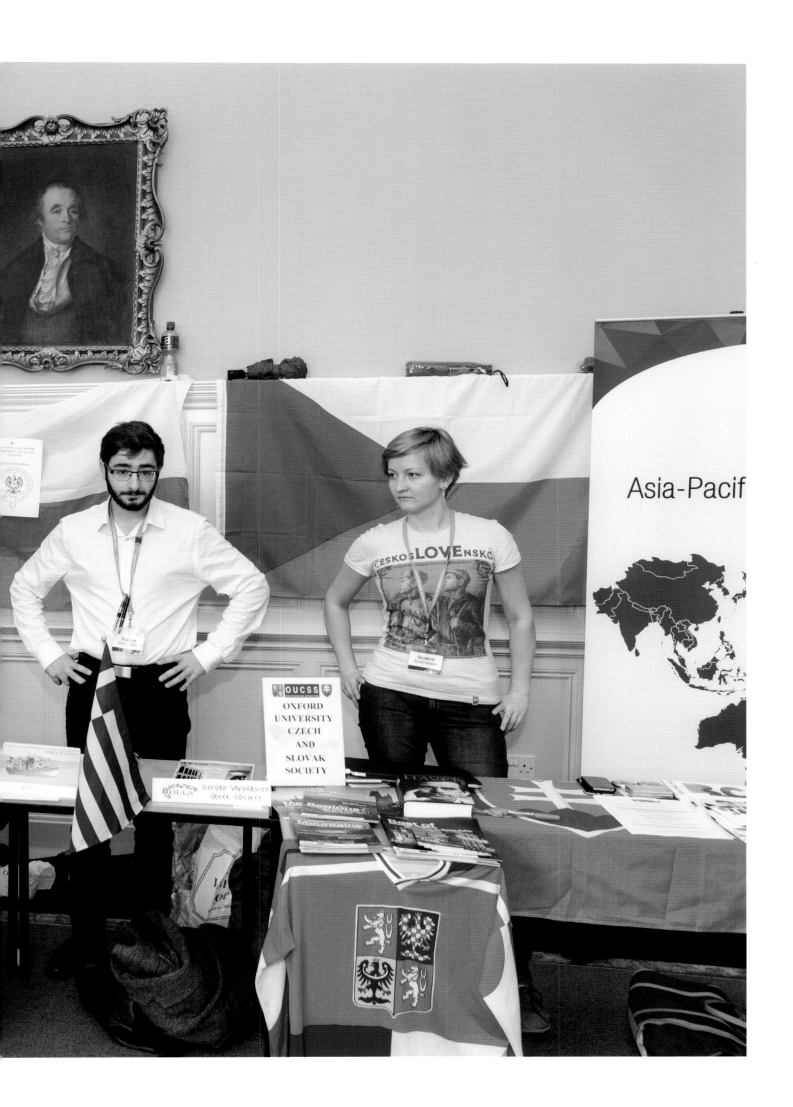

Oxford University Press.

Previous page Freshers' Fair, Examinations School.

Peter Momtchiloff, philosophy editor, Oxford University Press.

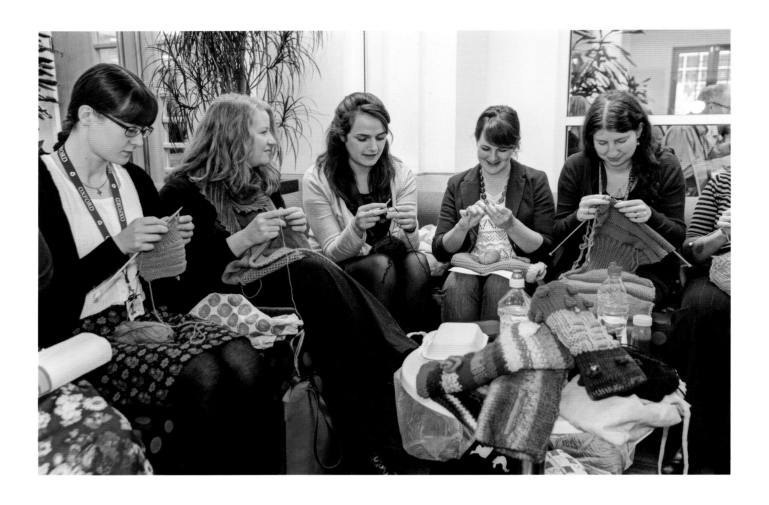

Oxford University Press knitting group.

Oxford University Press choir.

27

Richard Ovenden, Bodley's Librarian (director of the Bodleian
Libraries), in the tunnel known as the Gladstone Link, which joins
the Radcliffe Camera with the old Bodleian Library.

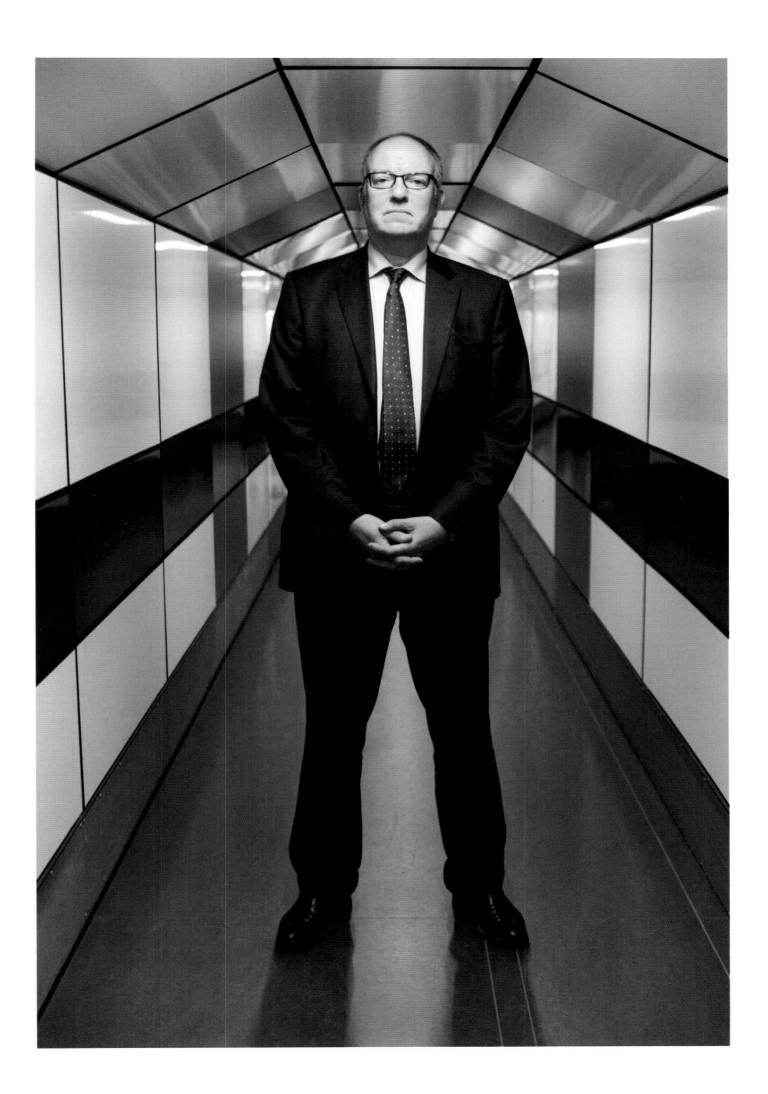

Christ Church Graduate Common Room cake club. After dinner
on a Monday night, students take it in turns to bake a cake for other
members of the Graduate Common Room.

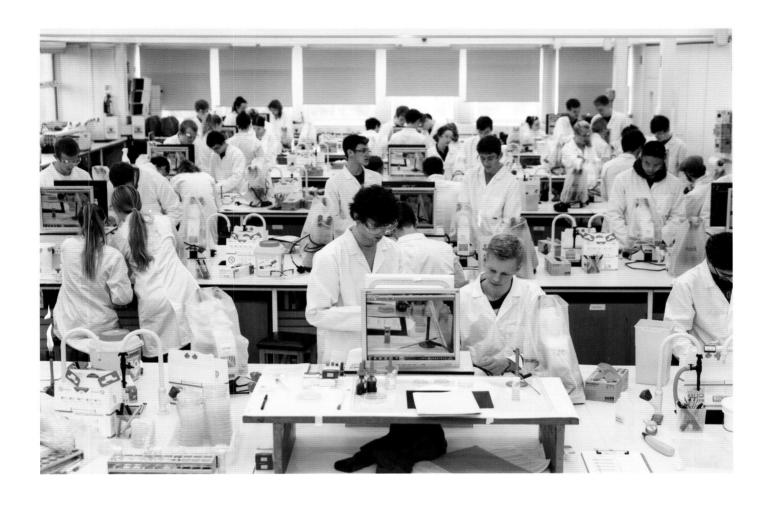

Department of Zoology laboratory.

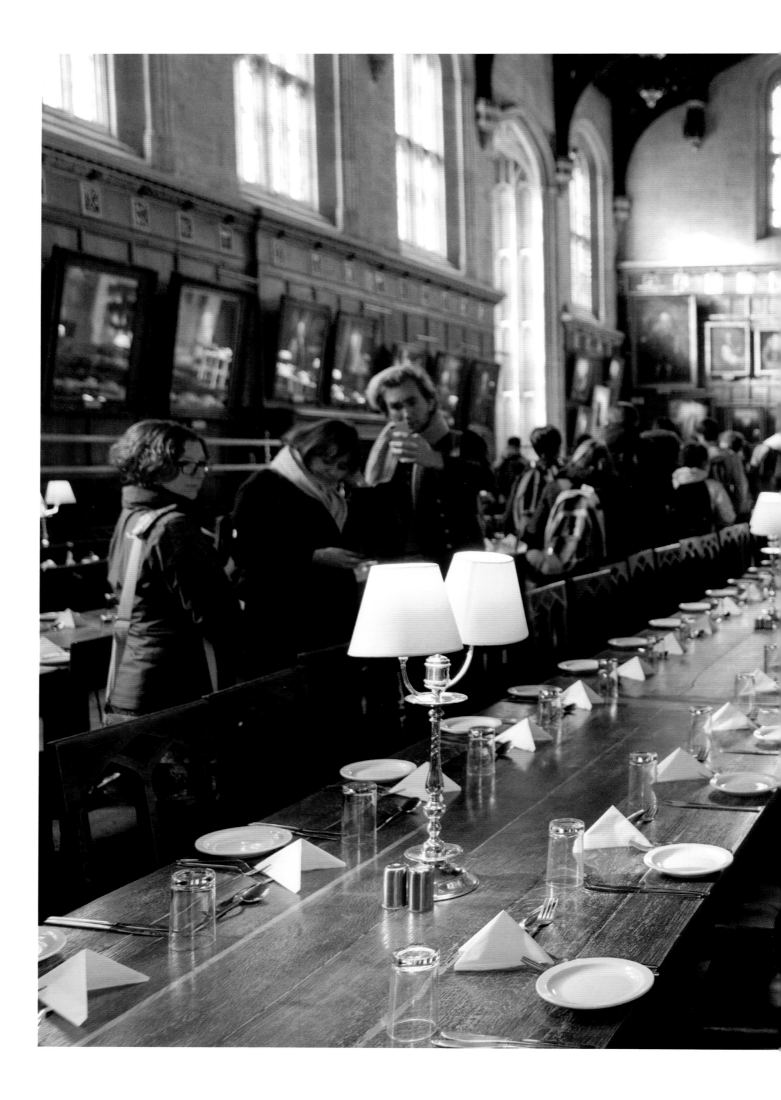

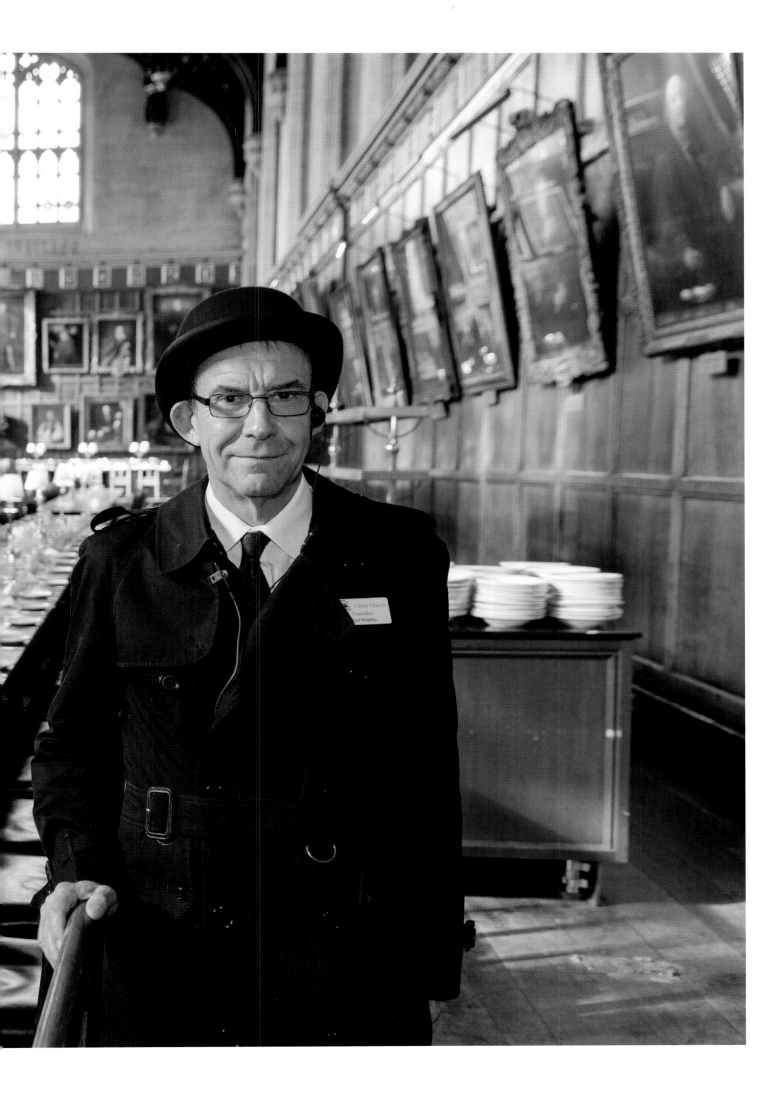

Simon Tsang, Custodian, Christ Church.

Previous page Chris Clements, Hall Assistant. Christ Church, where some of Harry Potter was filmed, is now the most visited of the colleges, and here tourists are streaming into the main dining hall.

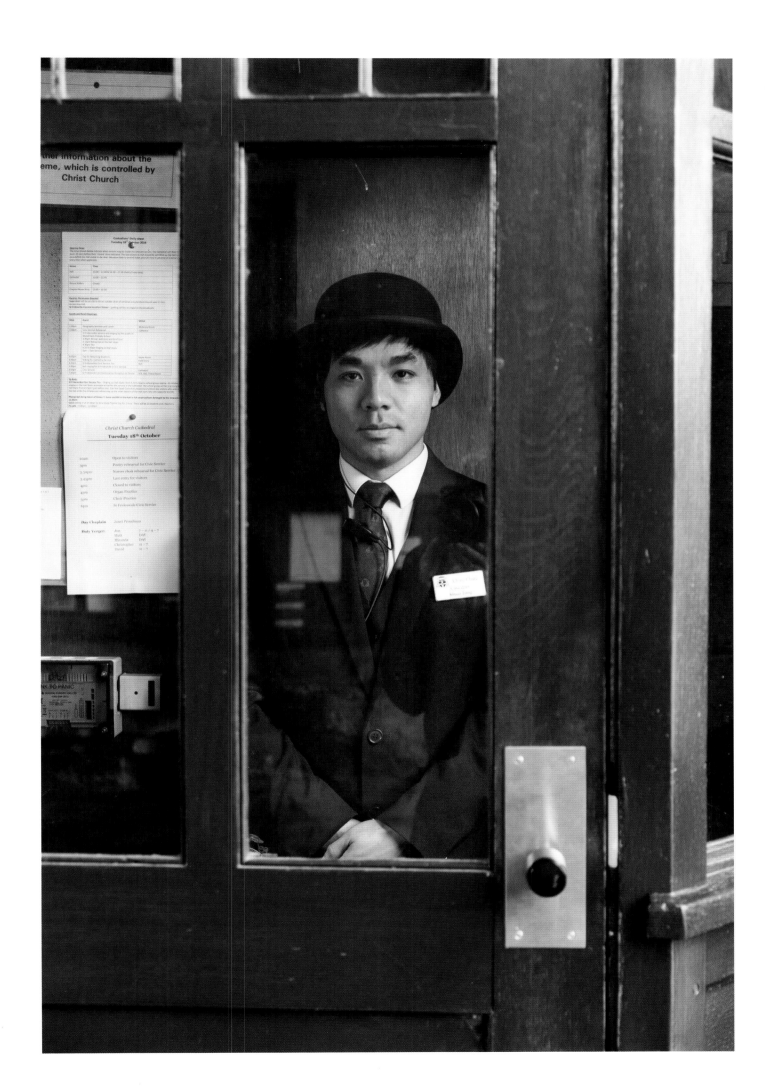

David Leake, Head Gardener, Corpus Christi College.

Following page Nano Science and Technology D Phil students Sang Yem Pak and John Hong in the Department of Engineering Science nanotech laboratory.

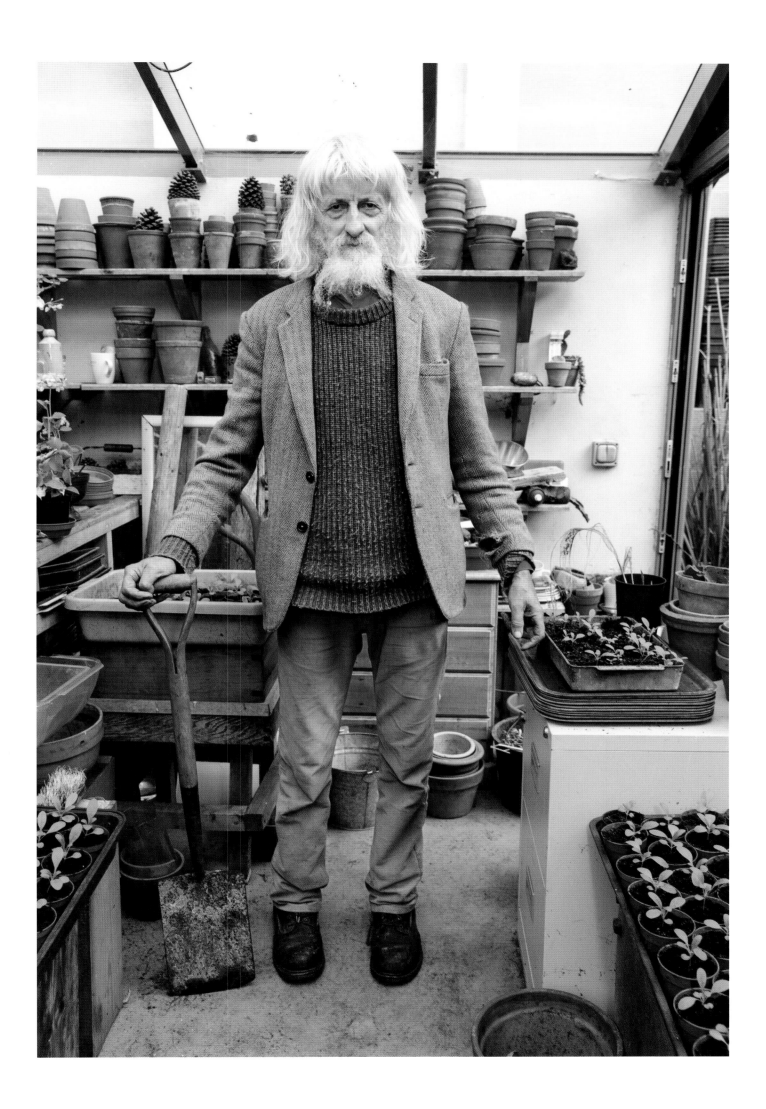

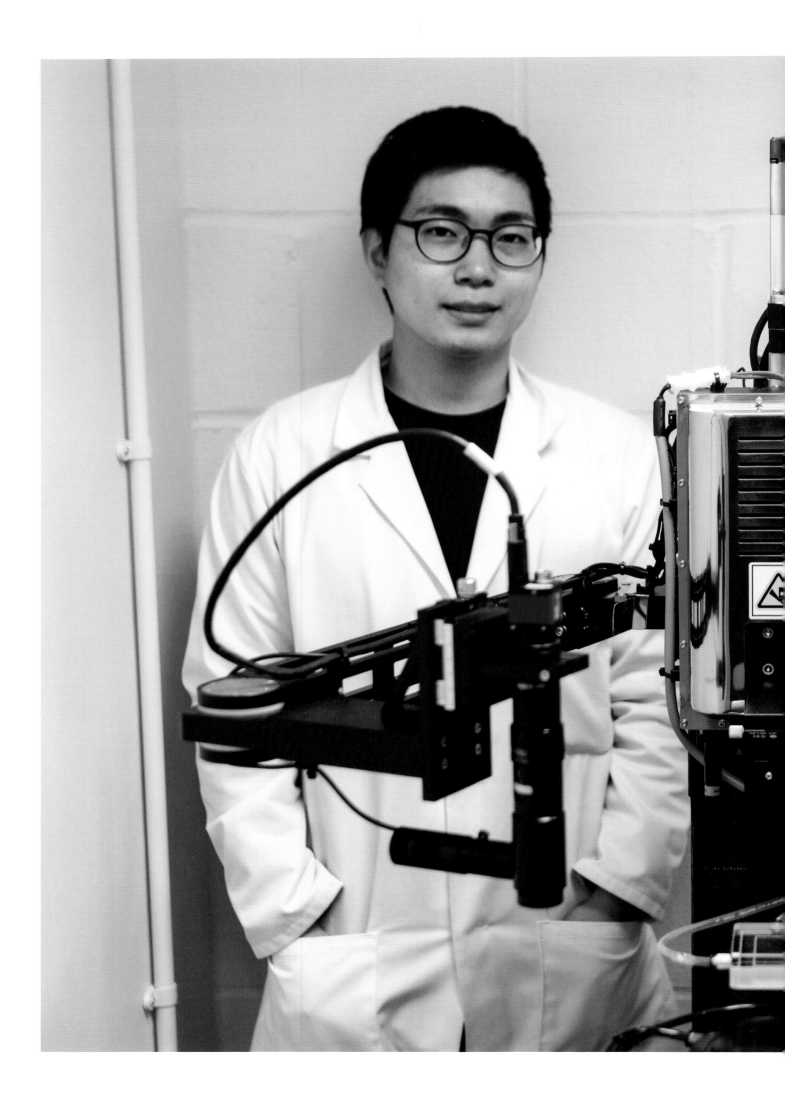

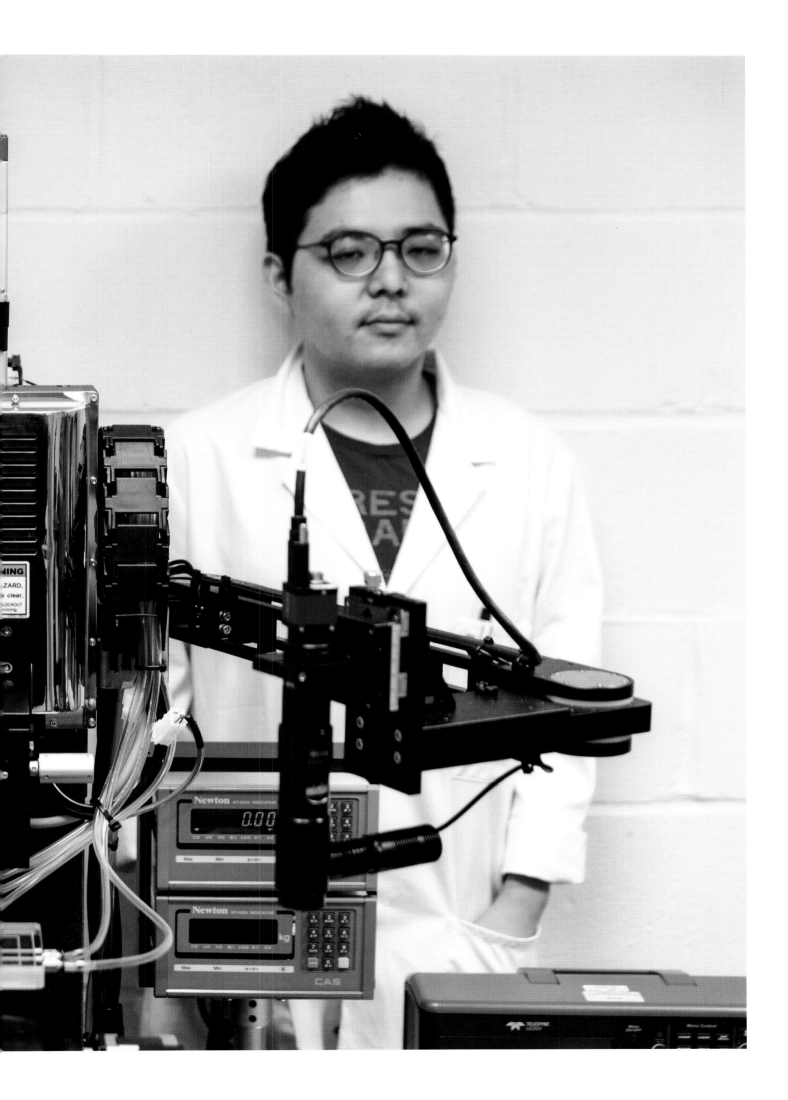

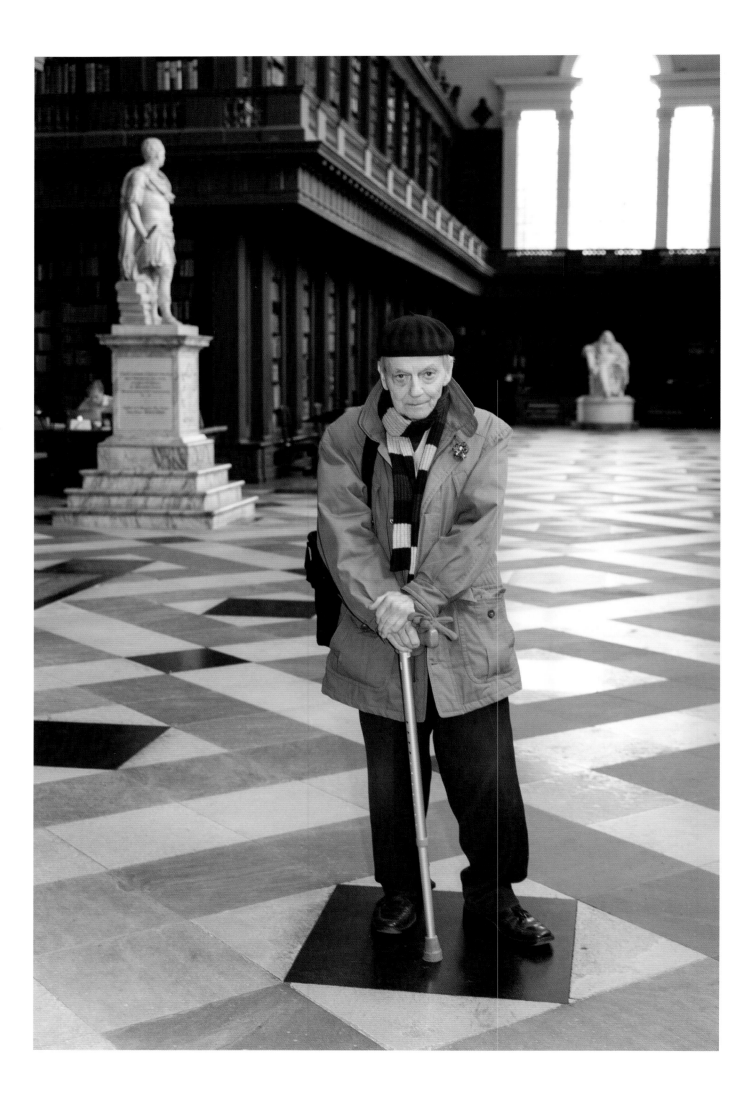

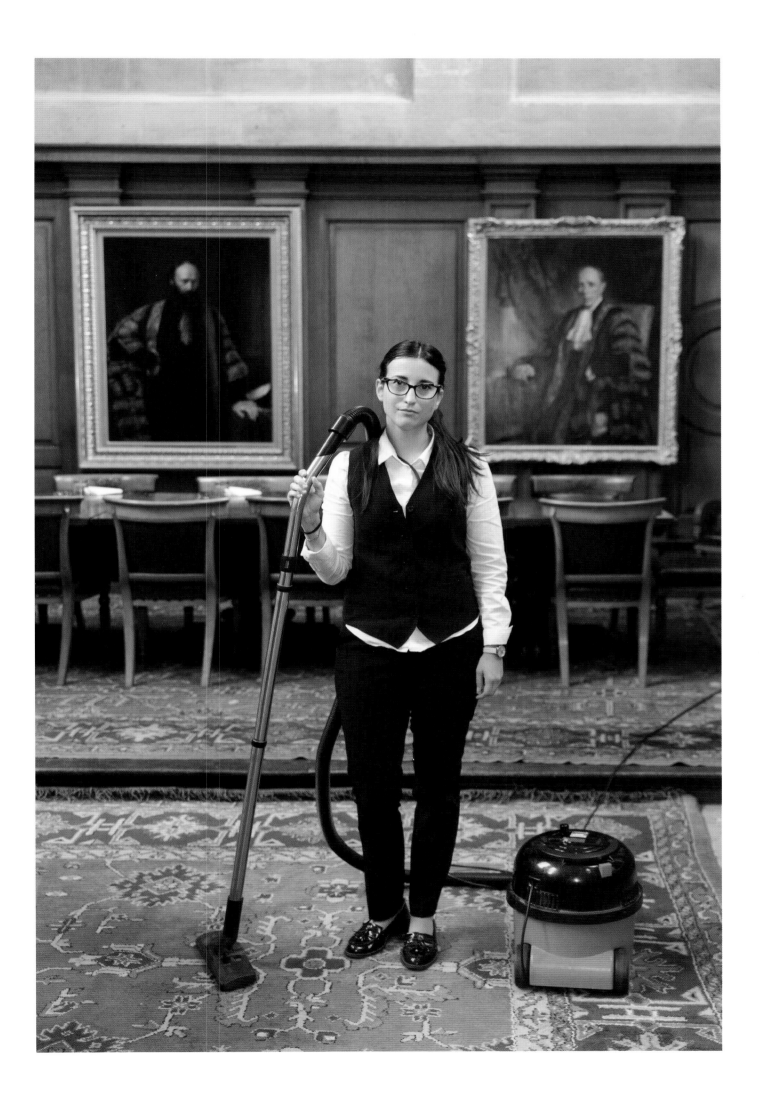

Drinking port is a great tradition at Oxford, and these are
'Lord Bathurst's fingers' at All Souls College, used to push
and pull the port bottle along the table.

Previous page (left) Sir Guenter Treitel, a fellow of All Souls
College, in the Codrington Library.

Previous page (right) Christina Fernandez Crespo, a cleaner
at All Souls College, in the dining room.

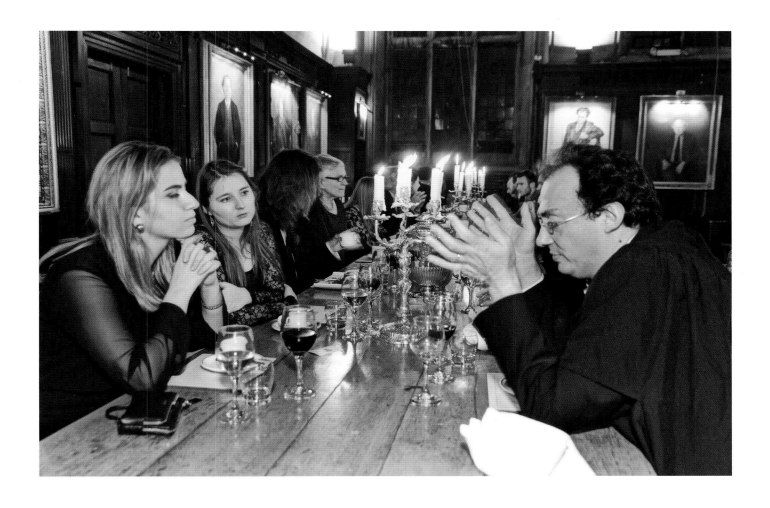

St Catherine's Day Feast, Balliol College.

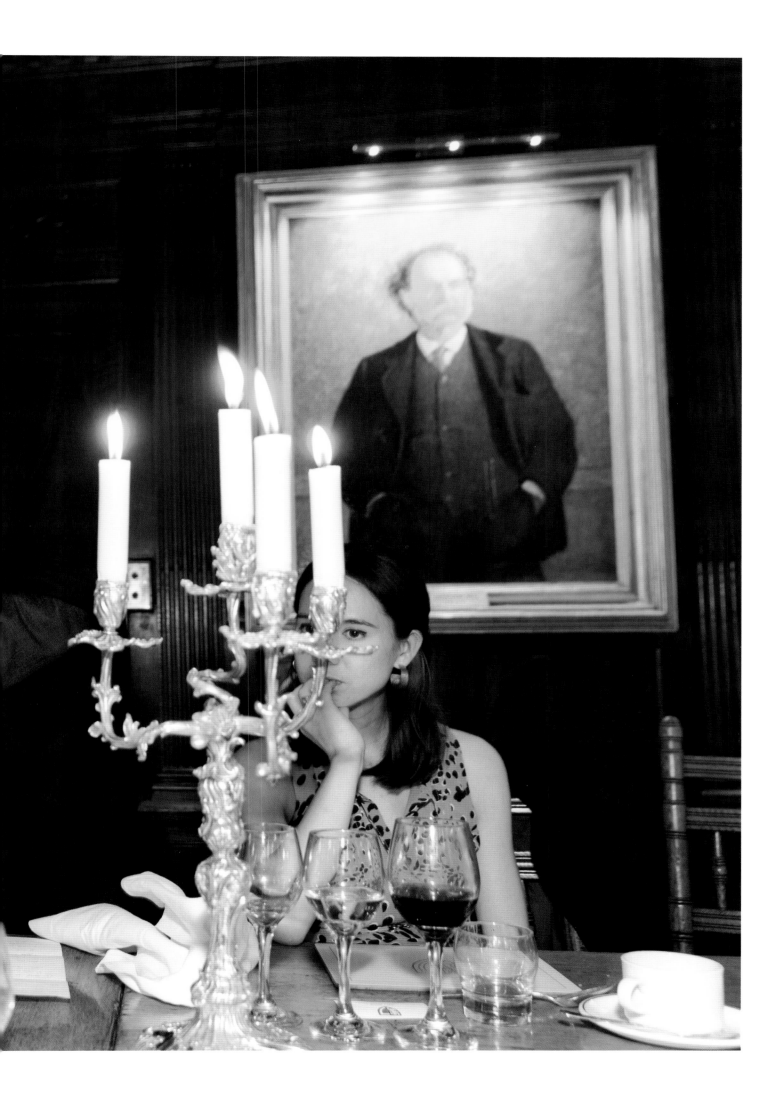

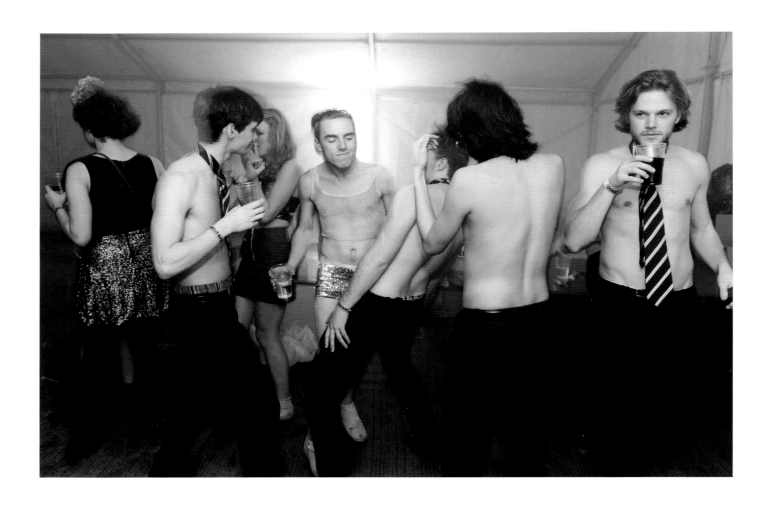

Queerfest, Wadham College.

Previous page The Master at St Catherine's Day Feast,
Balliol College.

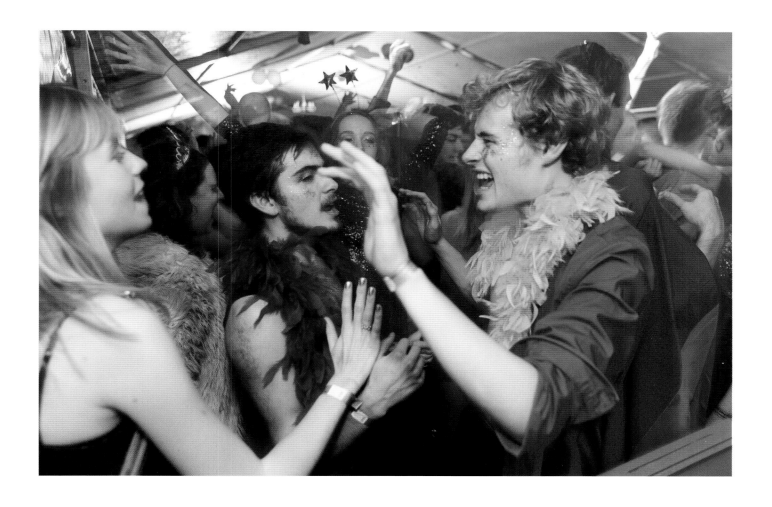

Queerfest, Wadham College.

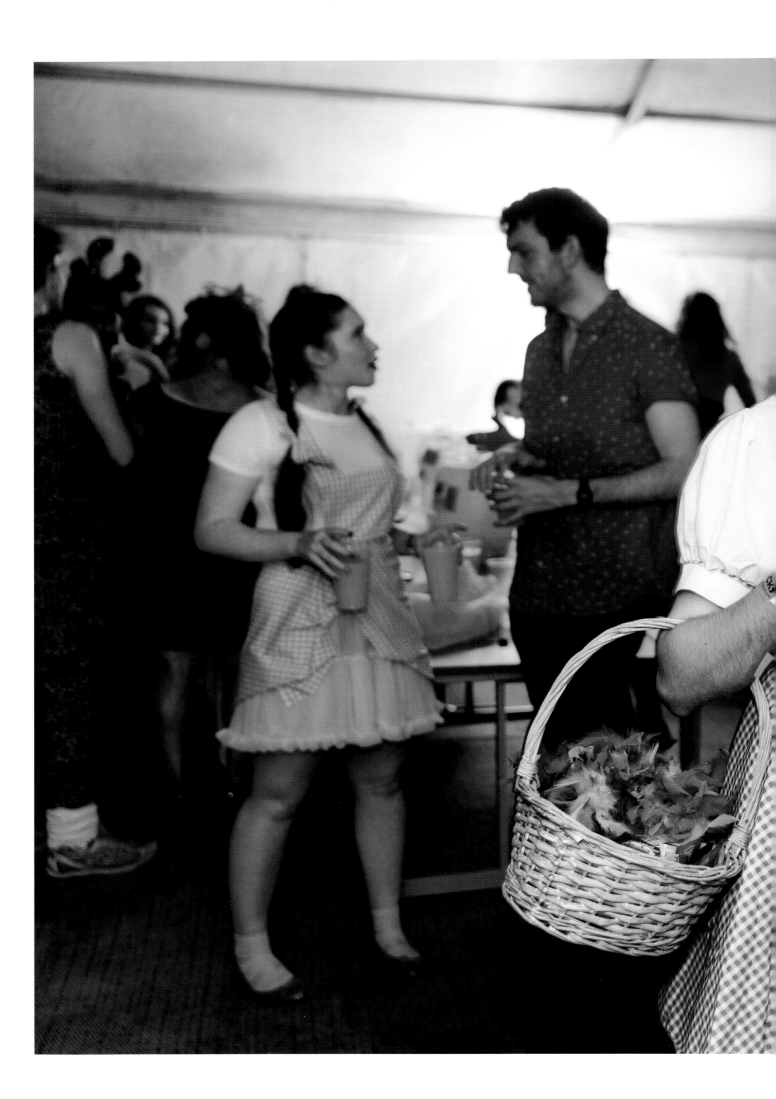

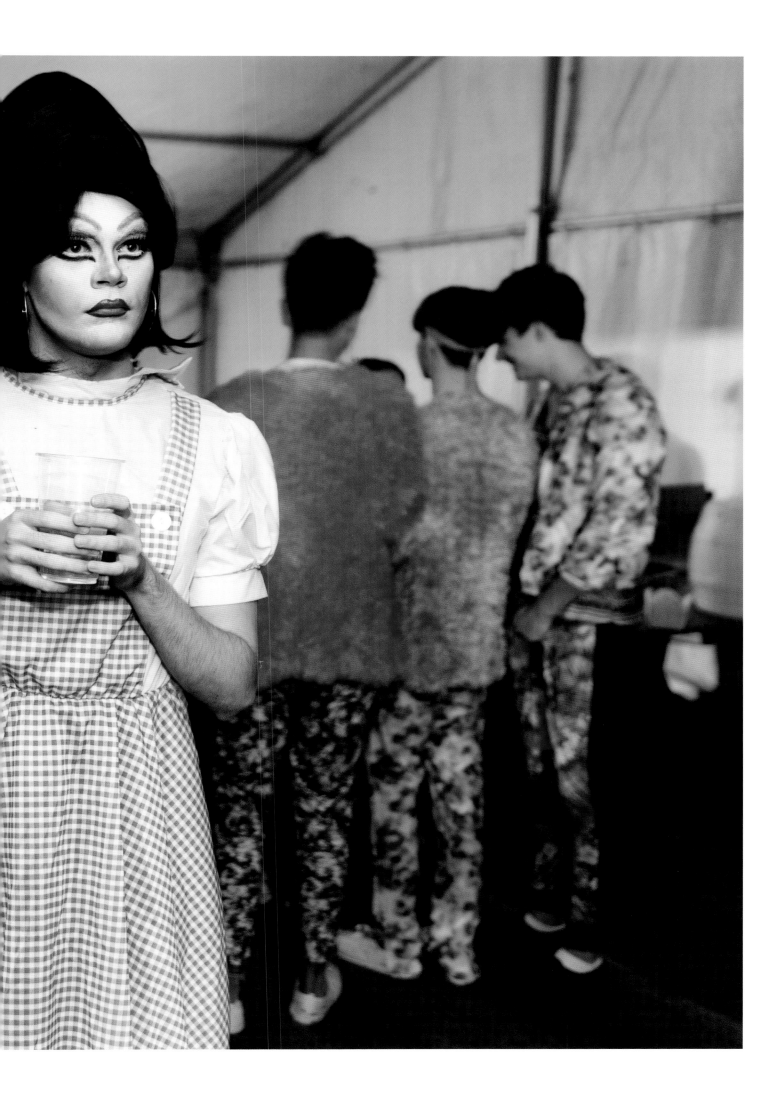

Professor of Poetry Simon Armitage was elected in Trinity Term 2015 to serve for four years.

Previous page Queerfest, Wadham College.

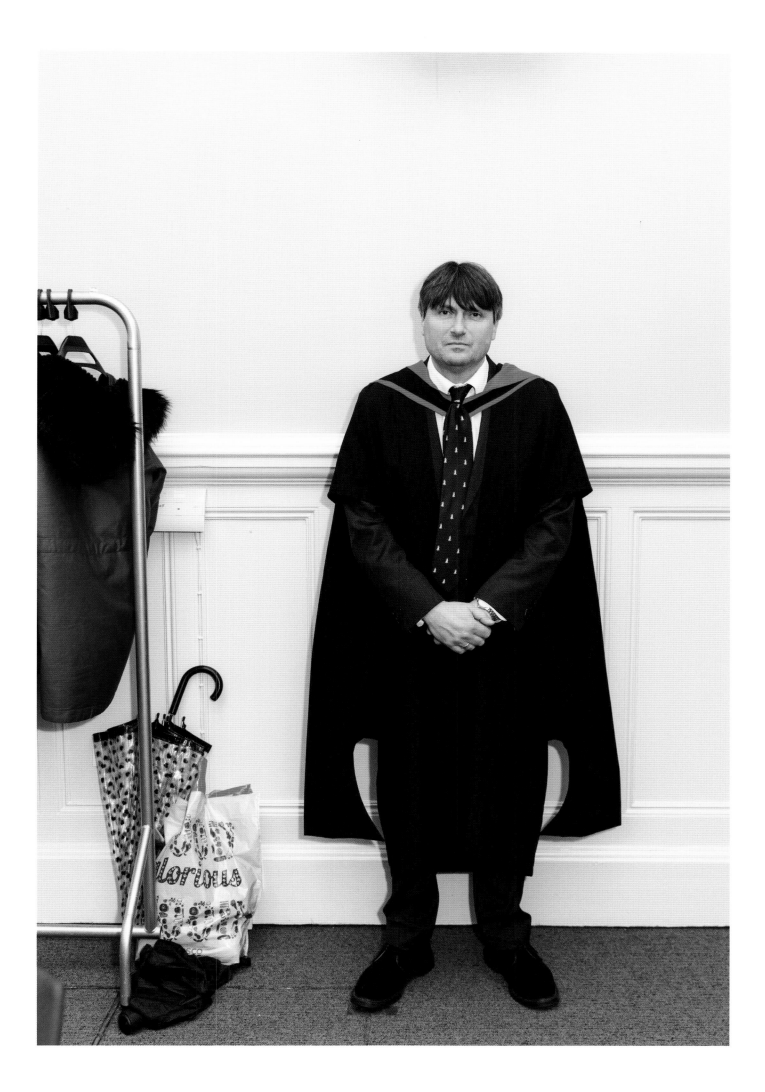

St Hilda's College has a traditional carol service called 'Carols on the Stairs'. This is so named because the service is so well attended that the stairs are utilized to fit all of the students into the hallway where the service takes place.

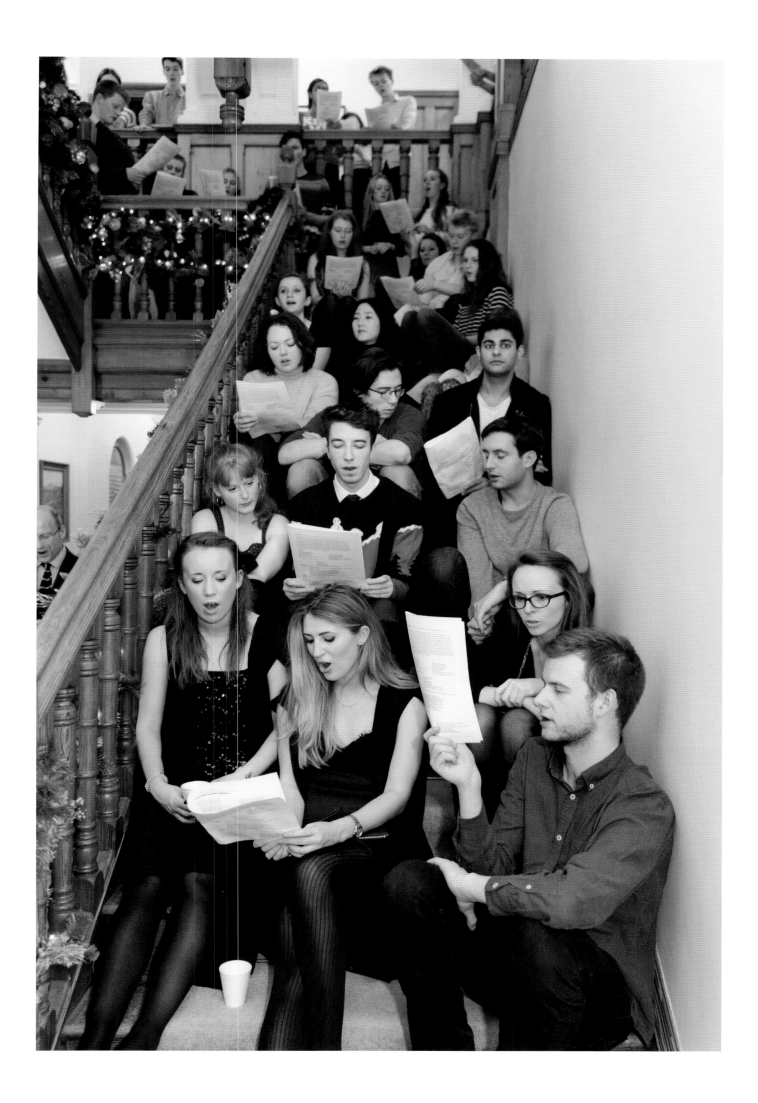

For the Christmas celebration dinner at St Edmund Hall
(known as Teddy Hall) the tradition is that students and staff
sing a few carols while standing on their chairs. The number
of carols sung has been reduced in recent years in deference
to health and safety regulations, so that now just the college
anthem, 'Teddy bears' picnic', is sung from on the chairs.

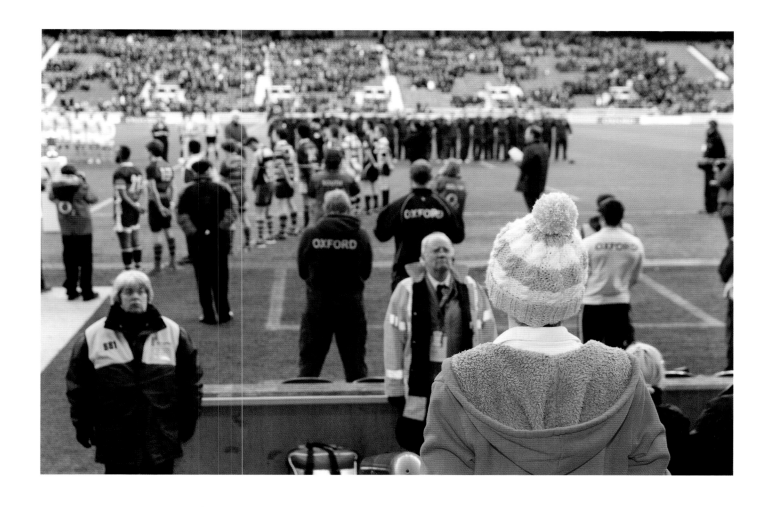

Varsity rugby match between Cambridge and Oxford, Twickenham.

Following page Oxford Union.

HILARY TERM

Bodleian Library books.

Upper Reading Room, Bodleian Library.

Advanced Processing Laboratory, Begbroke Science Park.

Previous page Duke Humfrey's Library, Bodleian Library.

Department of Materials, Begbroke Science Park.

Institute of Advanced Technology, Begbroke Science Park.

Institute of Advanced Technology, Begbroke Science Park.

Previous page Department of Zoology blue tit and great tit
research in Wytham Woods.

The Oxford Mobile Robotics Group,
Department of Engineering Science.

The Radcliffe Meteorological Station, outside
Green Templeton College, is the longest running
meteorological station in the world.

Following page Snell Dinner, Balliol College.

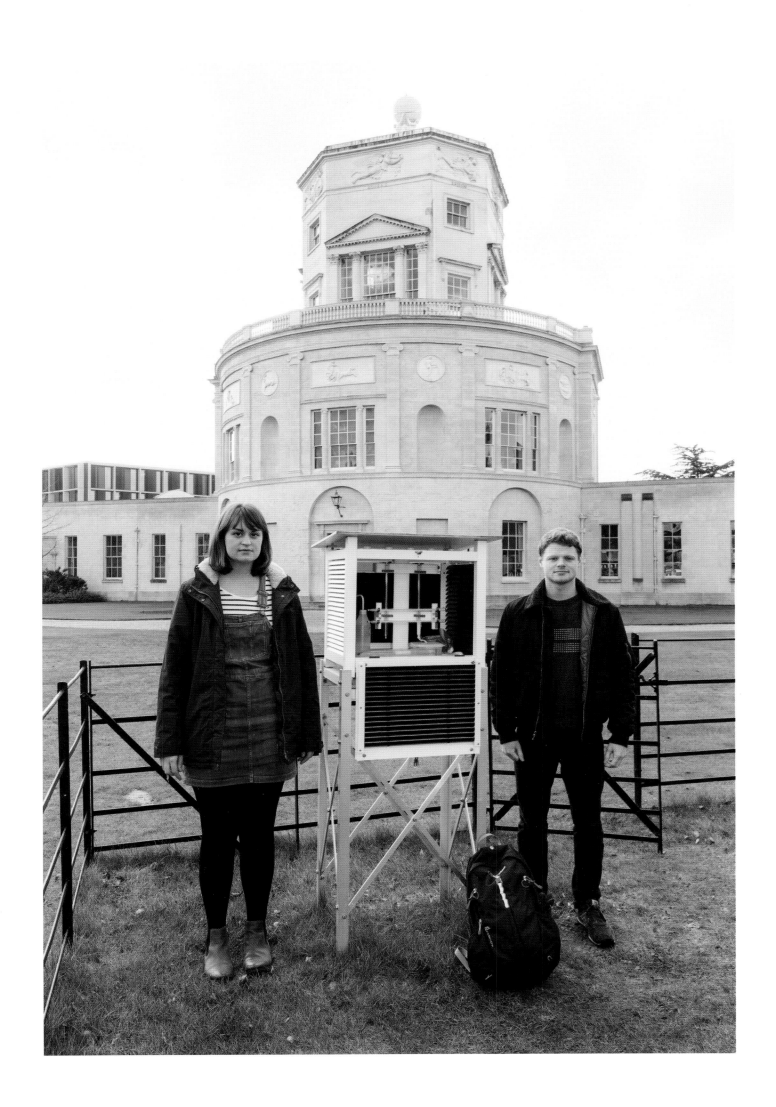

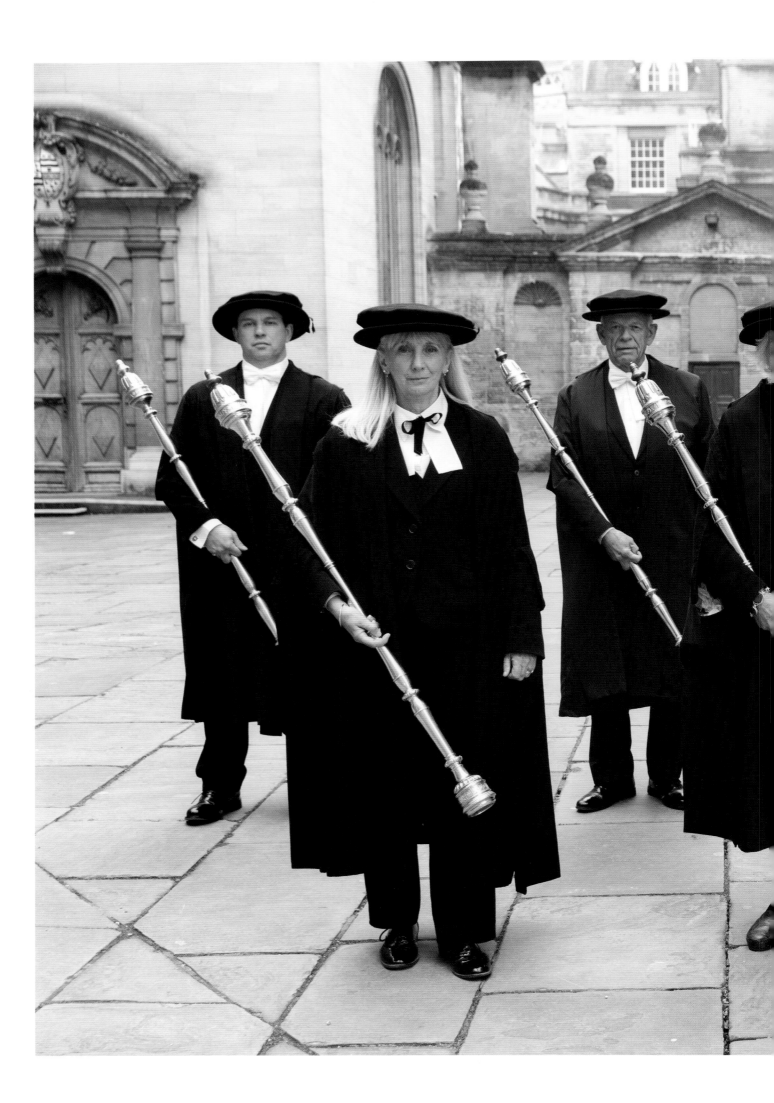

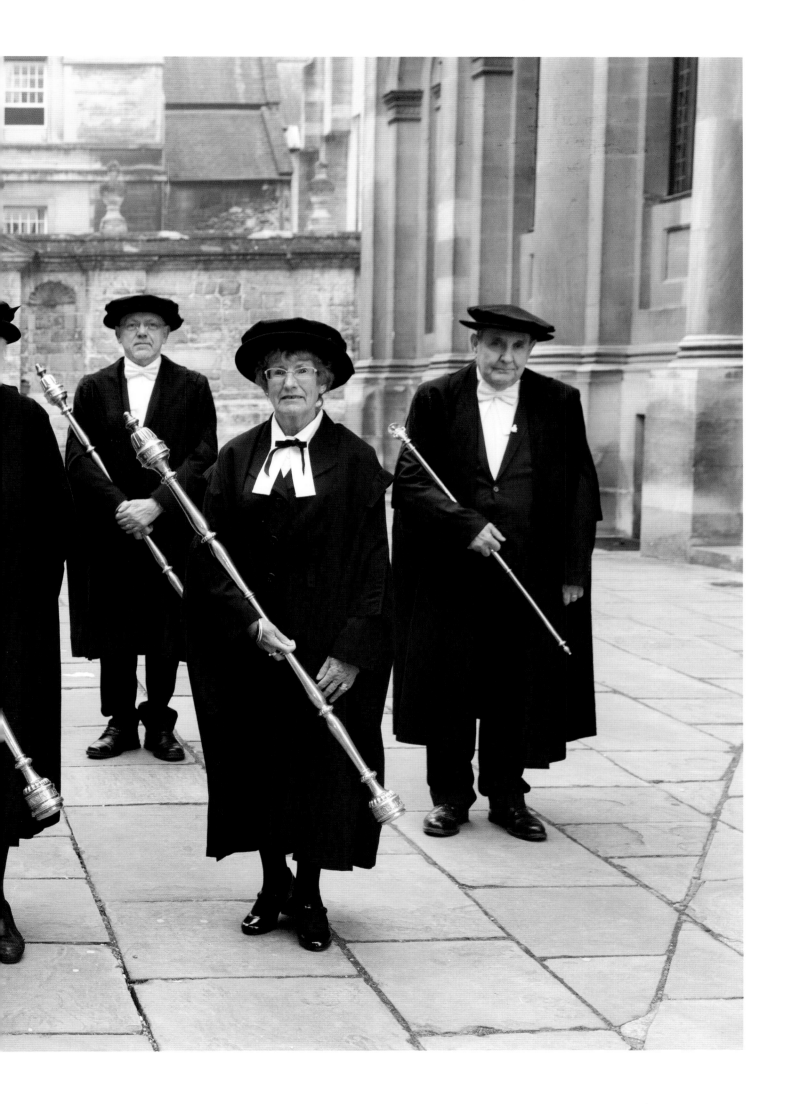

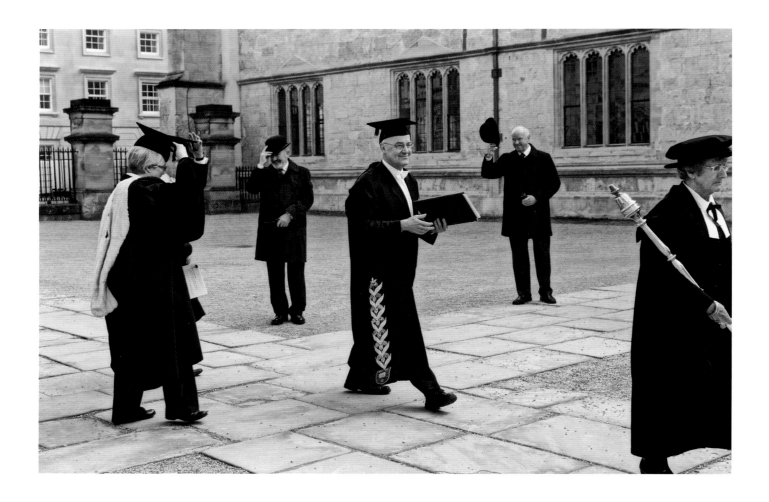

Admission of the Proctors. The proctors are responsible
for academic discipline within the university and this is the
ceremony to admit new members. Vice-Chancellor Professor
Andrew Hamilton (2009–15) is being greeted with a doff
of the hat as he walks by.

Previous page The bedels officiate at university events and
are drawn from both the university and the town.

Admission of the Proctors. The senior proctor passes the
vice-chancellor and raises his hat. This is known as 'giving
watch and ward'.

Life drawing class, Ruskin School of Art.

Following page Ruskin School of Art teaching staff outside the Green Shed.

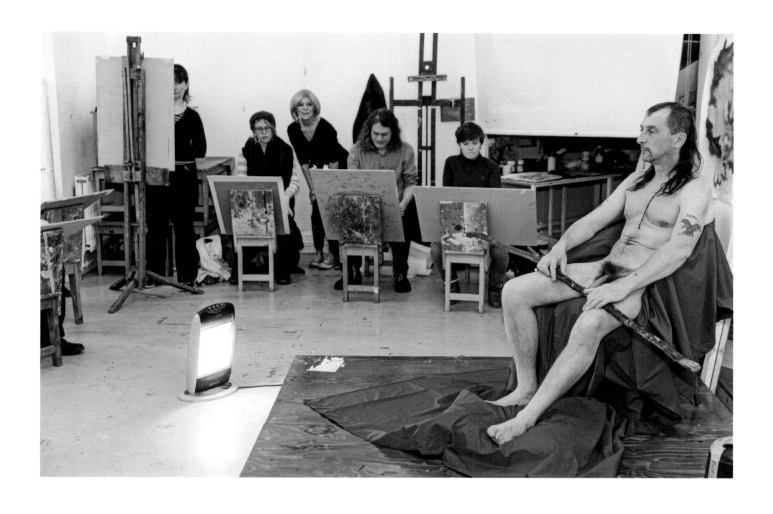

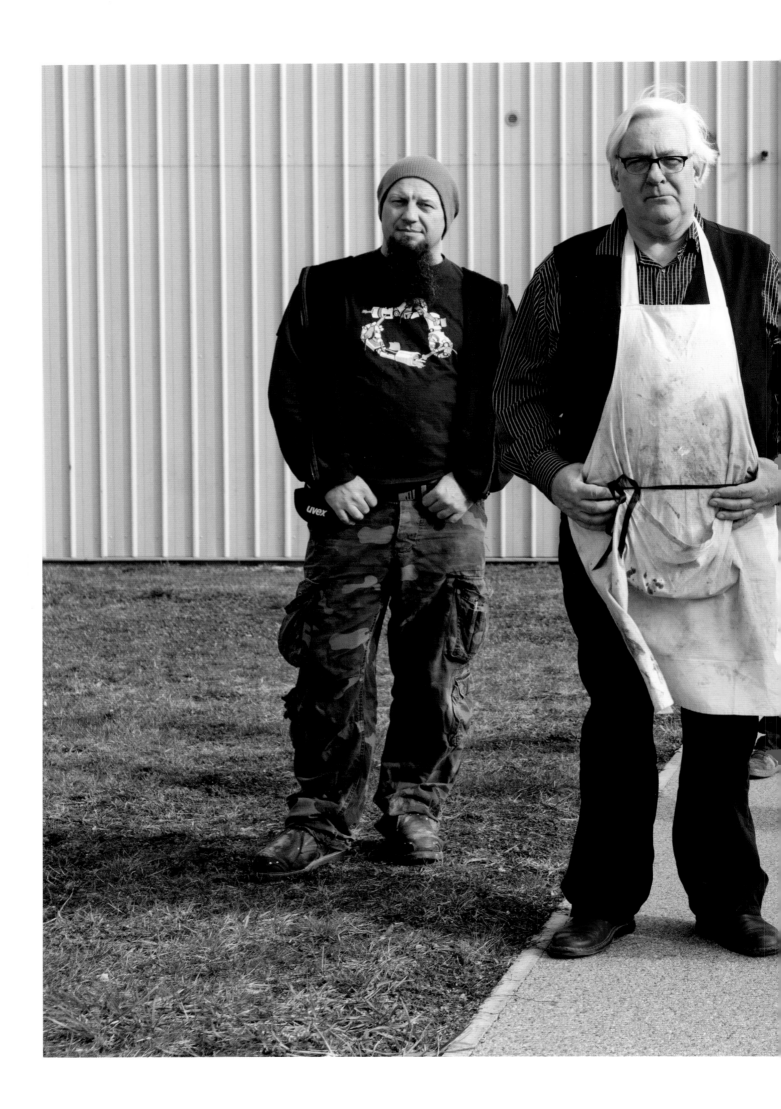

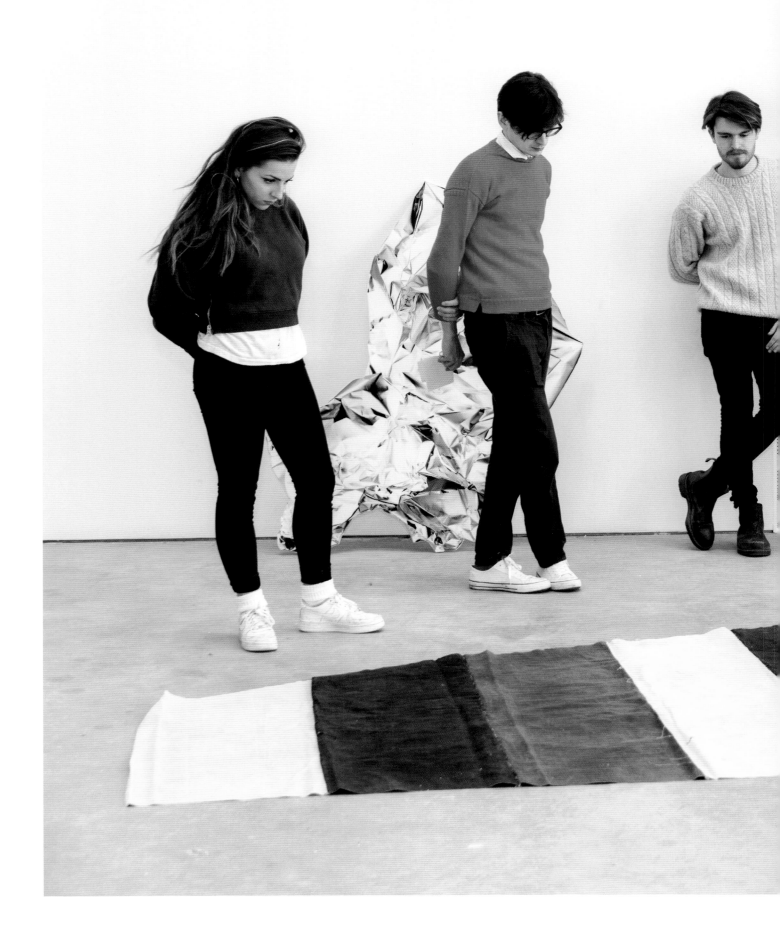

George Galloway at Oxford Union.

Previous page Tutorial, Ruskin School of Art.

Burns Night, St Hugh's College.

Stephen Hawking at the opening of the Weston Library.

Following pages Oxford and Cambridge Boat Race.

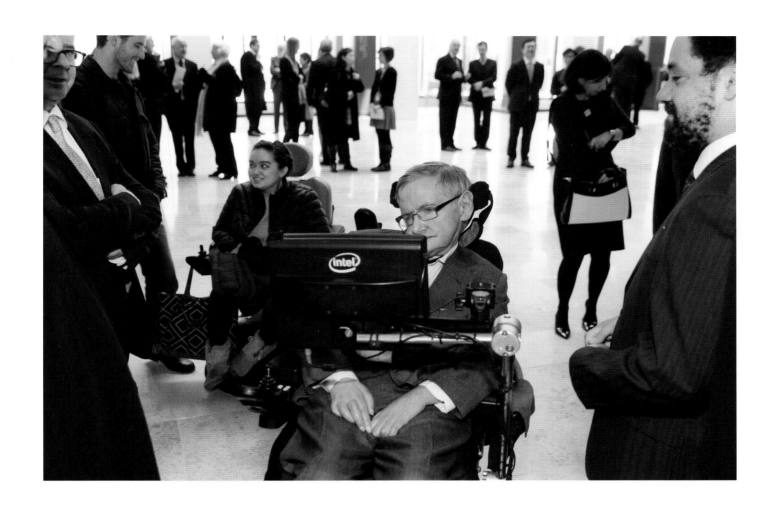

TRINITY TERM

Summer Eights, the annual summer term rowing competition.

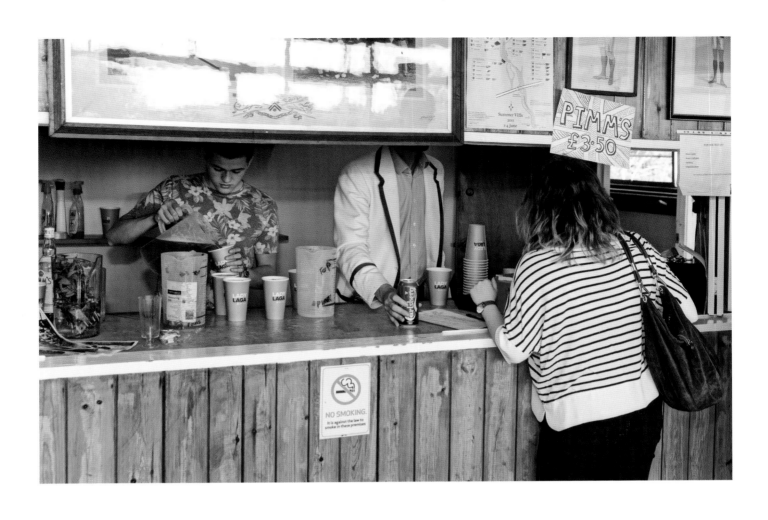

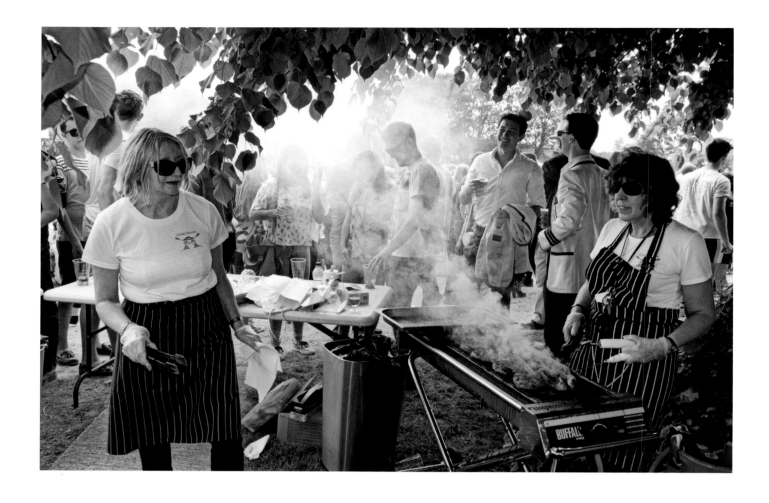

Summer Eights.

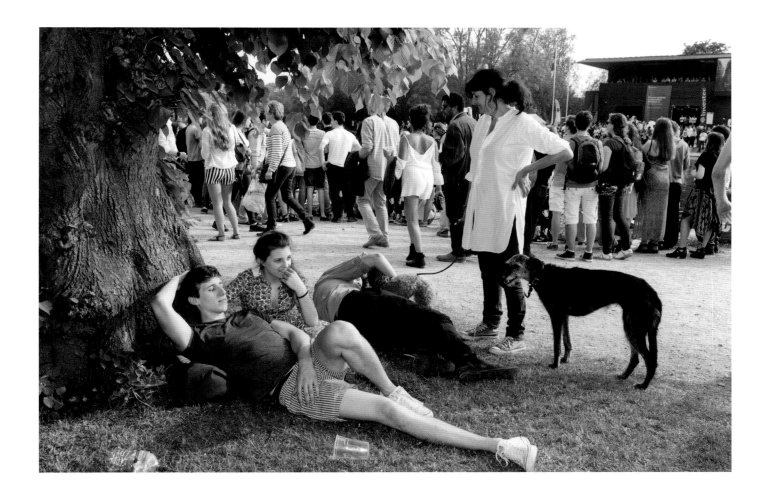

Summer Eights.

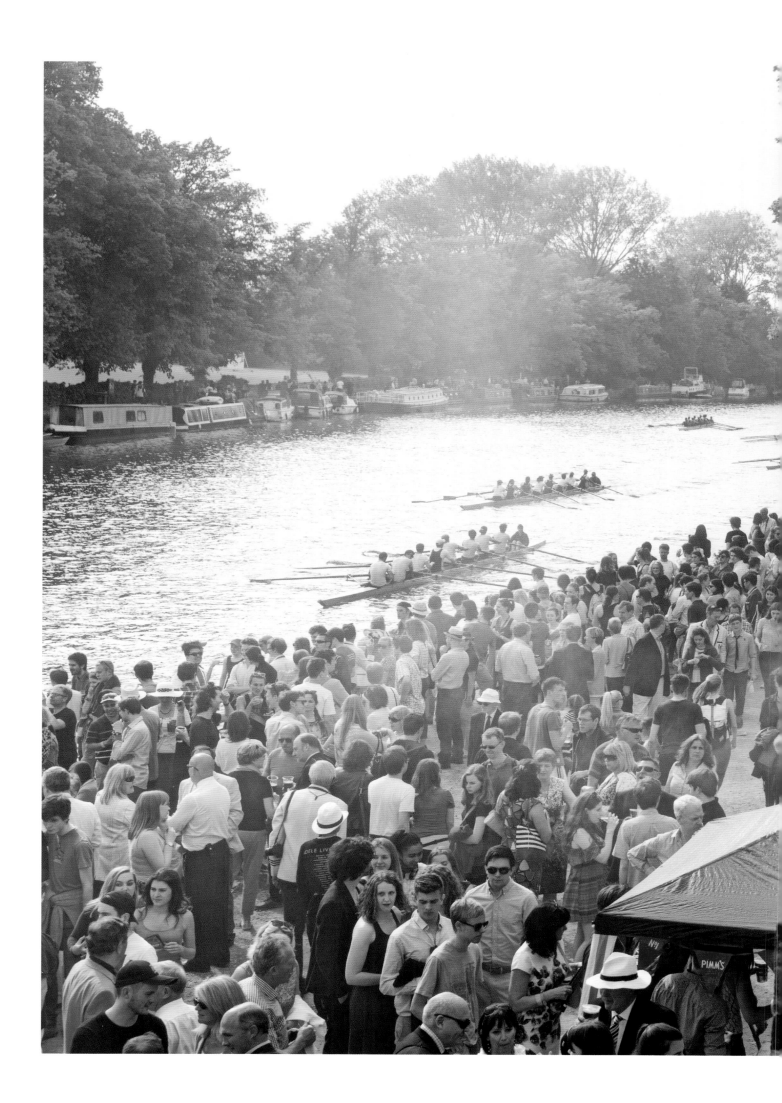

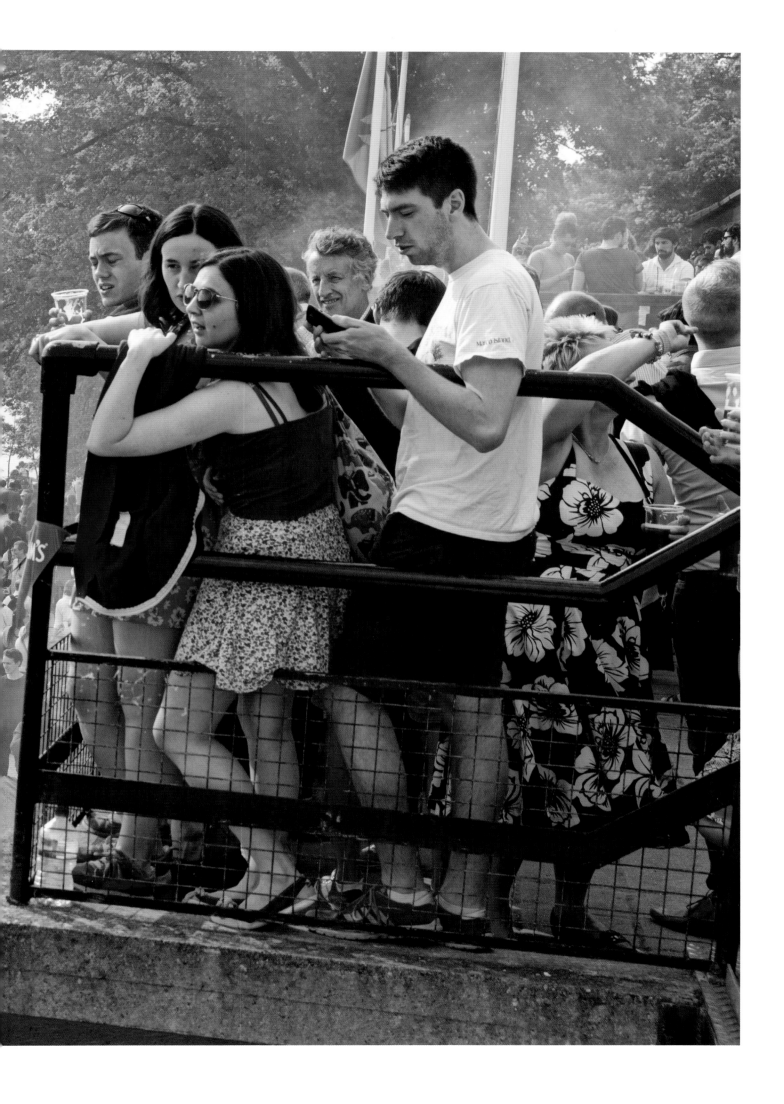

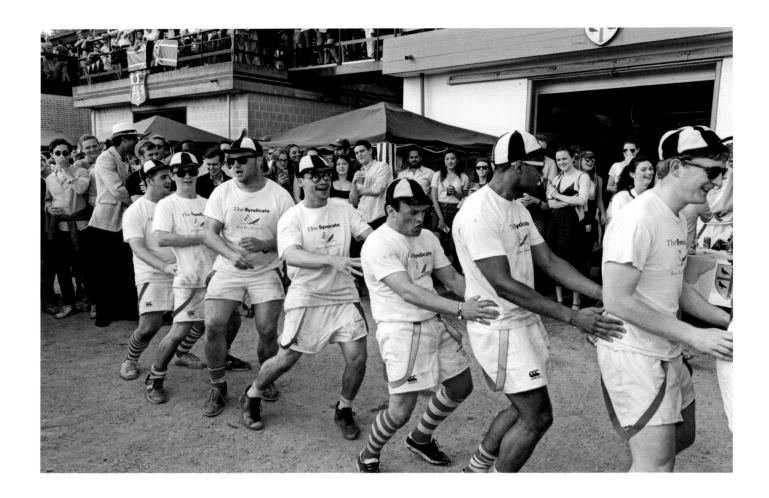

Oxford drinking clubs keep a fairly clandestine life, but from
time to time they put on a public display. Here The Syndicate,
the drinking club from Teddy Hall, puts on a dance routine
at Summer Eights.

Previous page Summer Eights.

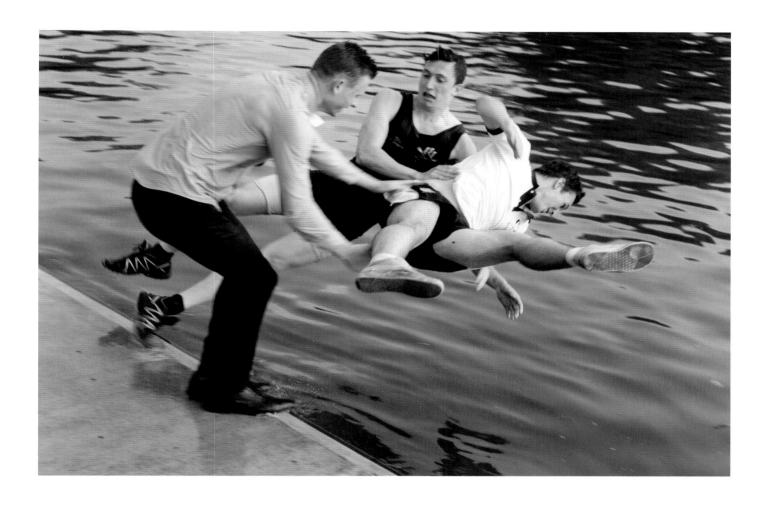

Oriel College rowers, Summer Eights. As part of the annual
summer term rowing competition the winning team and often
other college rowers are thrown into the river.

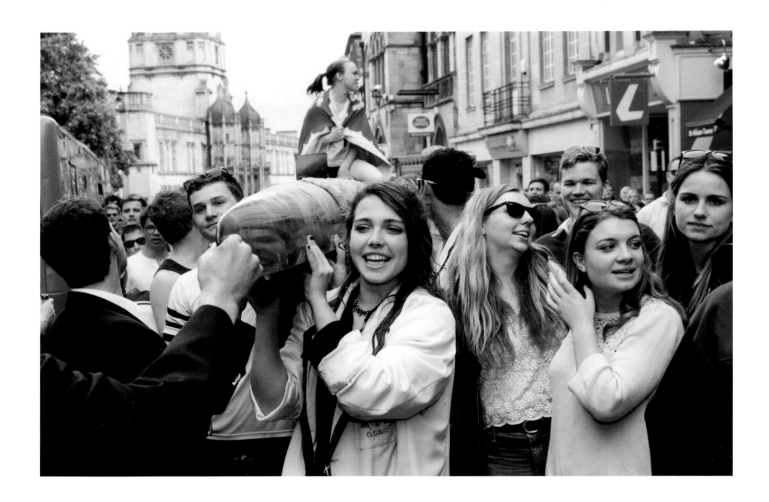

Summer Eights is a huge event in the university calendar. Whichever crew becomes 'Head of the River' (that is, wins the four-day race by not being bumped off the number one slot) traditionally carries an old wooden boat, with the cox on the top, as they sing and parade their way back to their college. In recent years Oriel College has consistently won this competition. When the boat is back at the college, it is smashed and burned later that evening after the celebratory dinner.

May Day morning. On May Day at 6 a.m., the choir at Magdalen College sing the Eucharist from the tower. Singing also happens at many other colleges, but Magdalen is the best known. Huge crowds gather underneath the tower, and many students have been partying all night.

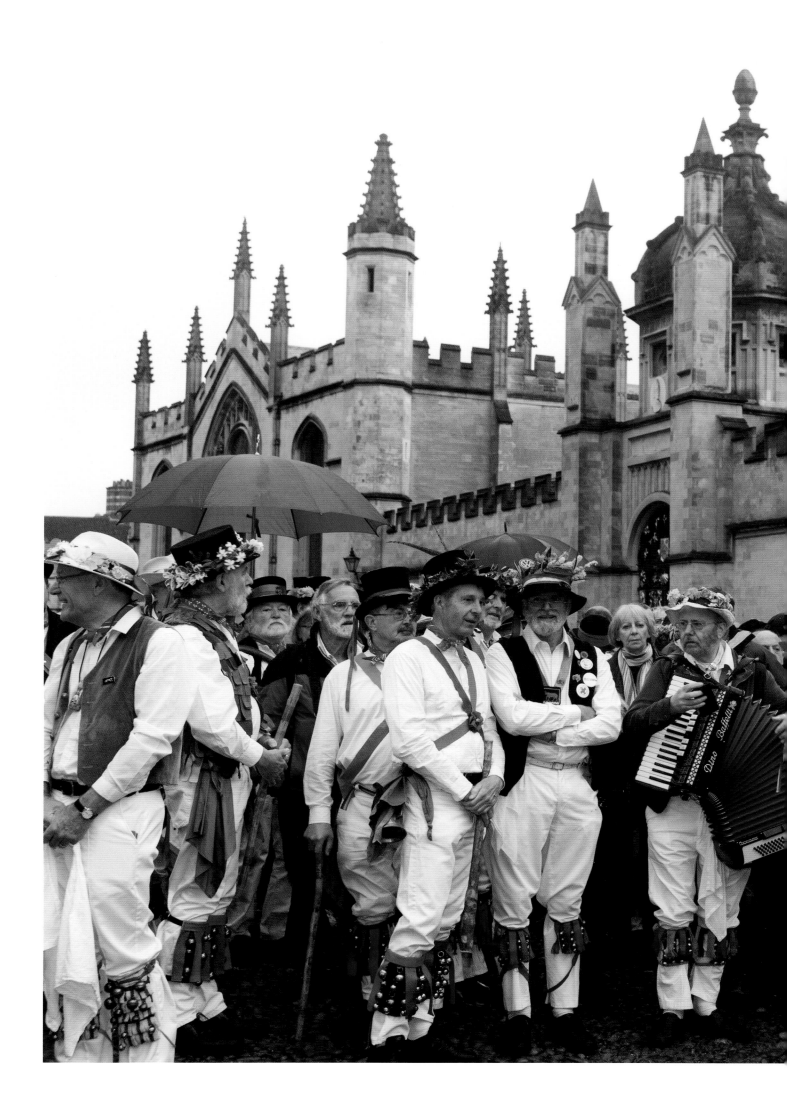

Professor Louise Richardson, Vice-Chancellor of the University
of Oxford. Appointed on 1 January 2016, she is the first woman
to hold the position of vice-chancellor since the university's
records began nearly 800 years ago.

Previous page May Day, Radcliffe Square.

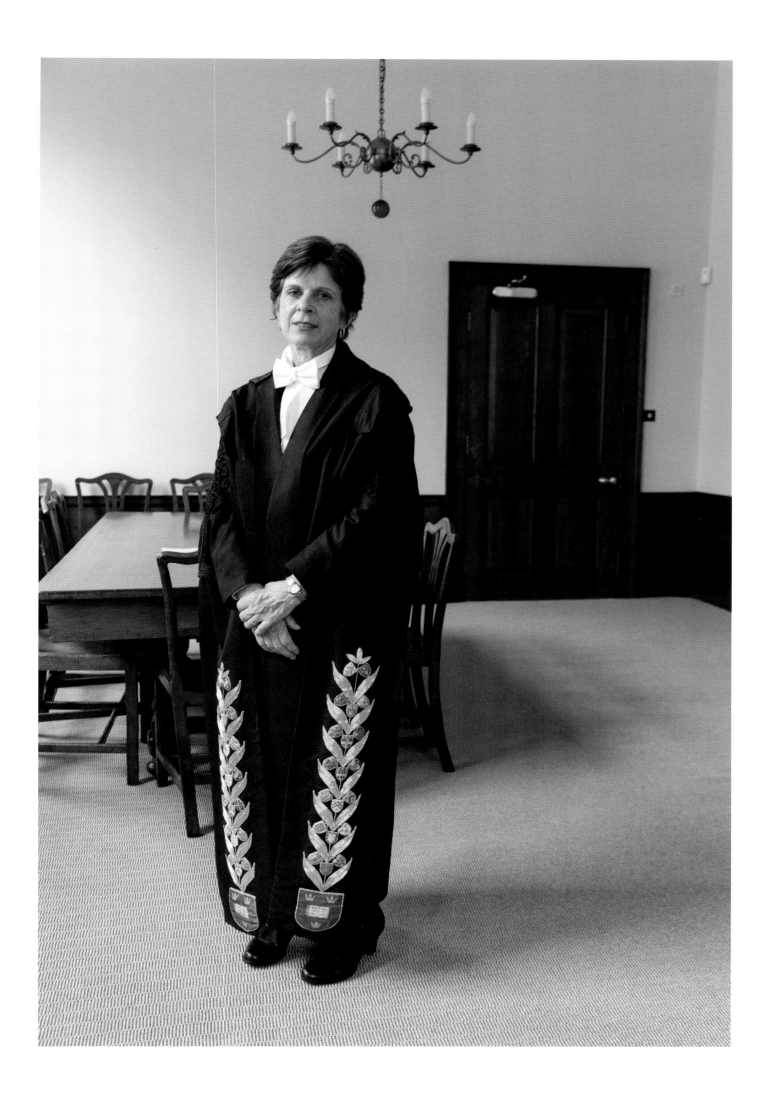

Officers of the Pembroke College Junior Common Room
Art Collection. In 1947 an art collection was started by the
then students of Pembroke College. By astute buying and the
occasional sale, they have amassed a significant collection of
post-war British art. The art collection is open to the public
for two days a week and JCR members are allowed to
borrow the art to display in their rooms.

Many colleges own tortoises and a tortoise keeper is often
elected. Every year an inter-college tortoise race is held
at Corpus Christi College.

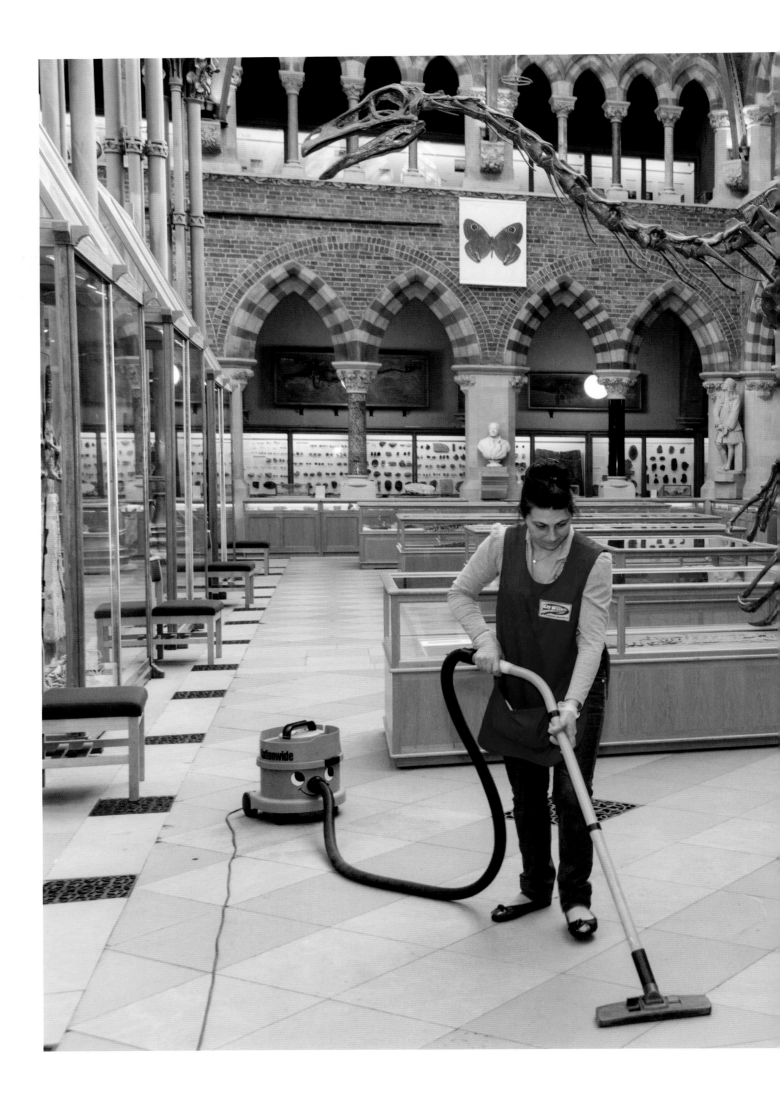

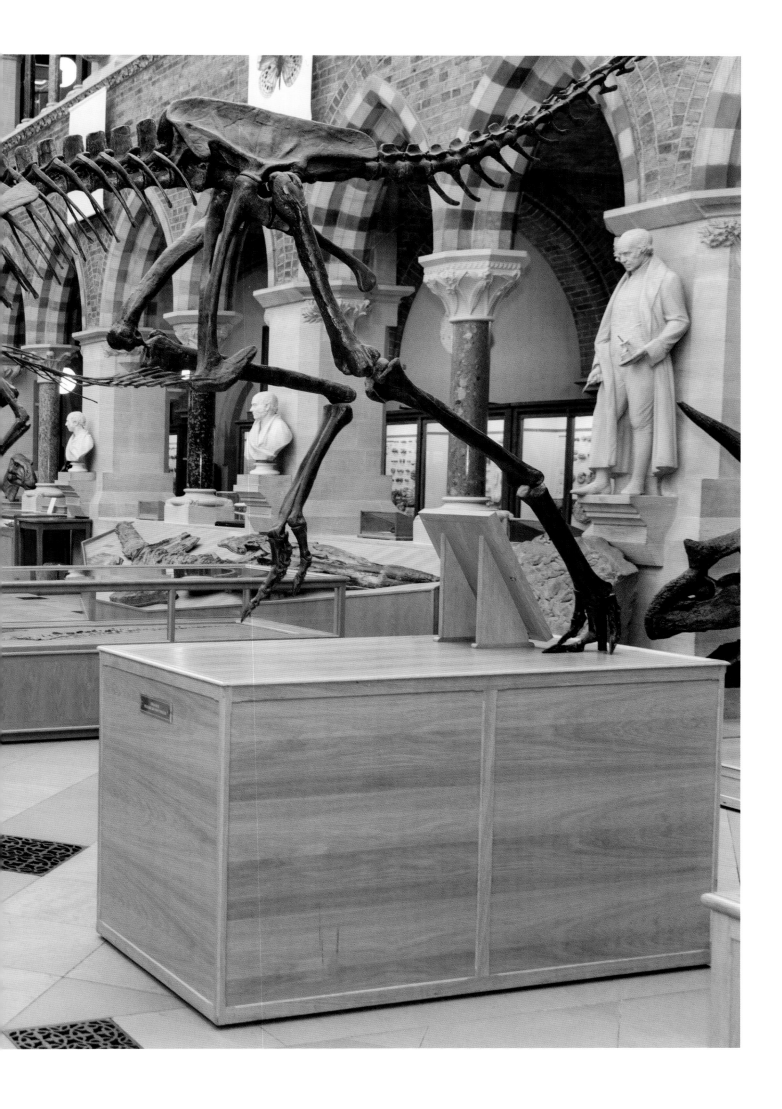

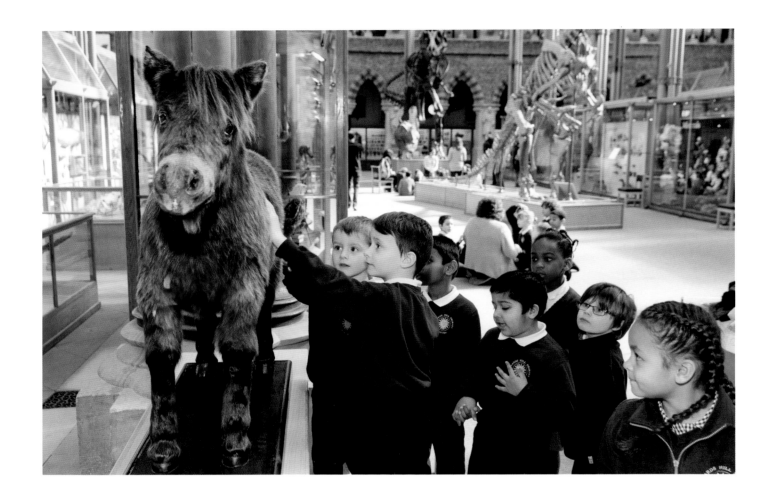

This stuffed pony used to be a big attraction for the many
schoolchildren visiting the Oxford University Museum of
Natural History. But in 2015, to much dismay, the pony was
withdrawn as it became worn out and was replaced with
a new touchable bear.

Previous page Oxford University Museum of Natural History.

Oxford University Museum of Natural History.

Lincoln and Brasenose Colleges are neighbours
and there is one passageway that connects the
two colleges. On Ascension Day students from
Brasenose are invited to visit Lincoln College and
enjoy a free glass of beer. However, to discourage
too much indulgence, the beer is 'poisoned' with
ivy, thus making it somewhat unpleasant to drink.
This is a long-standing tradition between the two
colleges and is said to be a penance either for a
Lincoln man killing a Brasenose man in a duel, or
for the murder of a Brasenose man by a town mob
at the gates of Lincoln because the students there
refused to open up and give him sanctuary.

Varsity athletics match, Sir Roger Bannister athletics track.

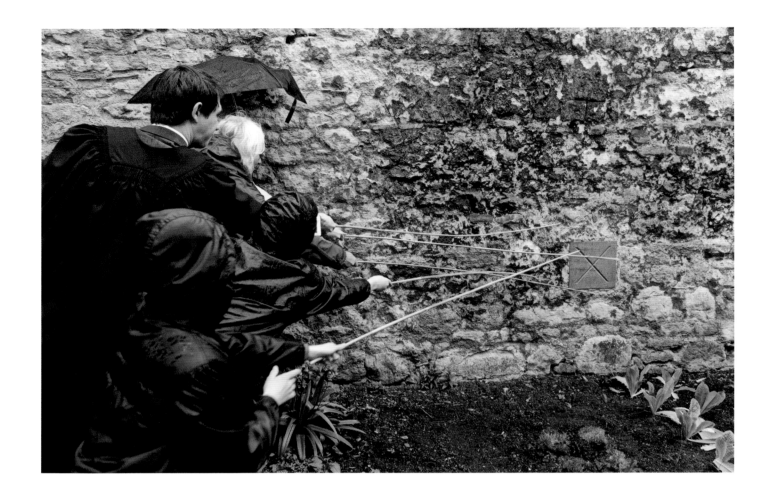

On Ascension Day, the annual 'beating of the bounds' ceremony
is carried out by schoolchildren from two parishes in the centre of
Oxford. The University Church of St Mary the Virgin's route takes
in All Souls College. In the dim, distant past the church sold a plot of
land to All Souls where there was once a cherry orchard. In recognition
of this the pupils are given cherry cake and squash in All Souls after
the boundary has been beaten.

Previous page Varsity athletics match, Sir Roger Bannister
athletics track.

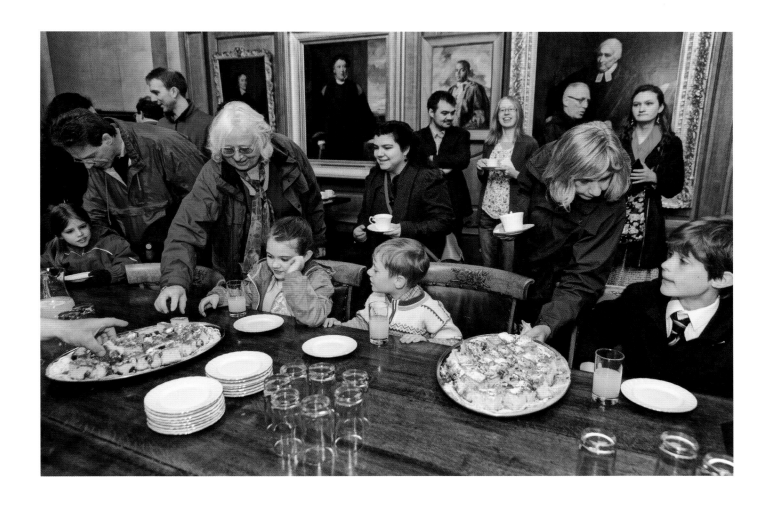

Cherry cake on Ascension Day, All Souls College dining hall.

Ailis Brennan, Ruskin School of Art degree opening.

Ruskin School of Art degree opening.

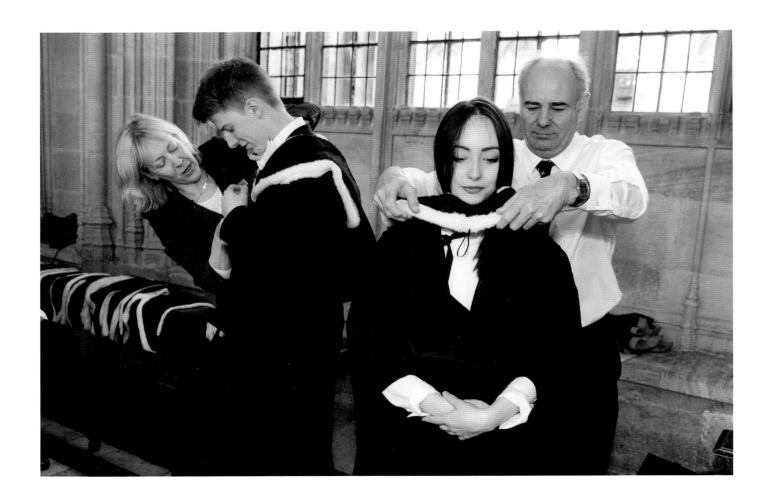

Graduation day, Divinity School, Keble College.

Previous page Two of the colleges visited by the beaters of the boundary are Oriel and Lincoln, where pennies are thrown down for the beaters who scramble to pick them up. Until recently the pennies were 'served hot', to discourage greed, but this has now been curtailed after a hot penny was caught in a woman's cleavage.

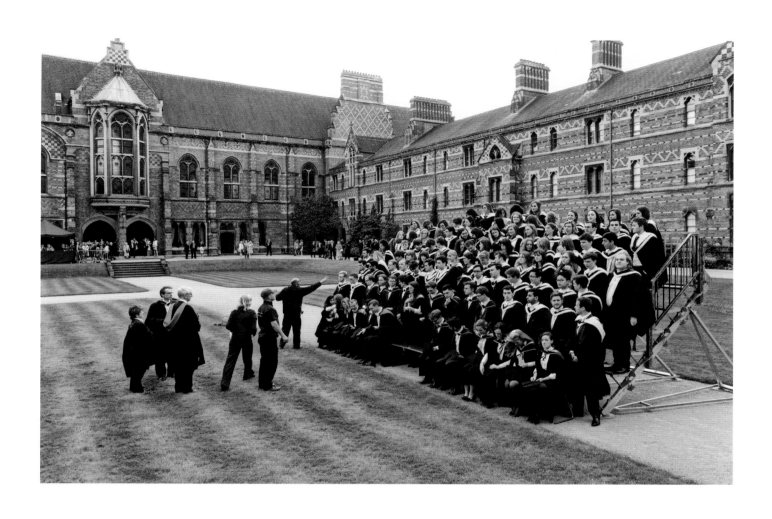

Graduation day, Keble College.

Exams are taken in full academic dress, known as subfusc, and a carnation is worn to depict where students stand in the exam process: a white carnation for the first exam, pink for an ongoing exam, and a red one for the final exam.

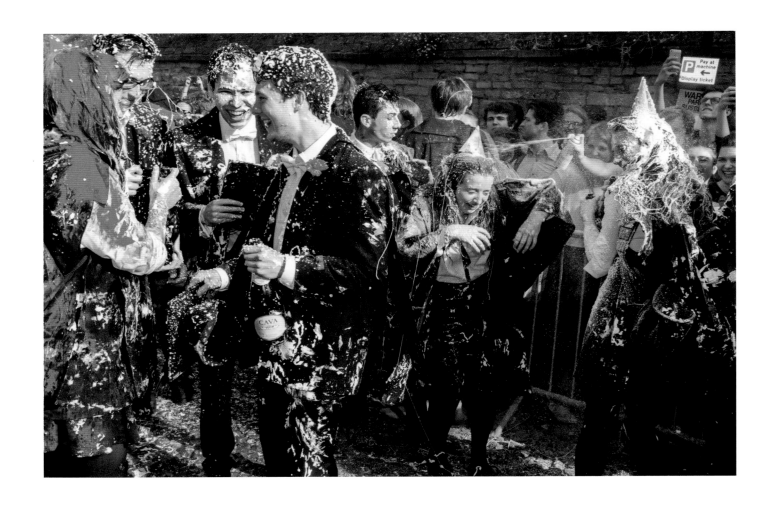

Trashing. After their final exam, students are trashed by friends
and colleagues as they leave the back of the examination hall.
This involves much foam spraying, drinking, and exploding
of bottles of champagne or fizz.

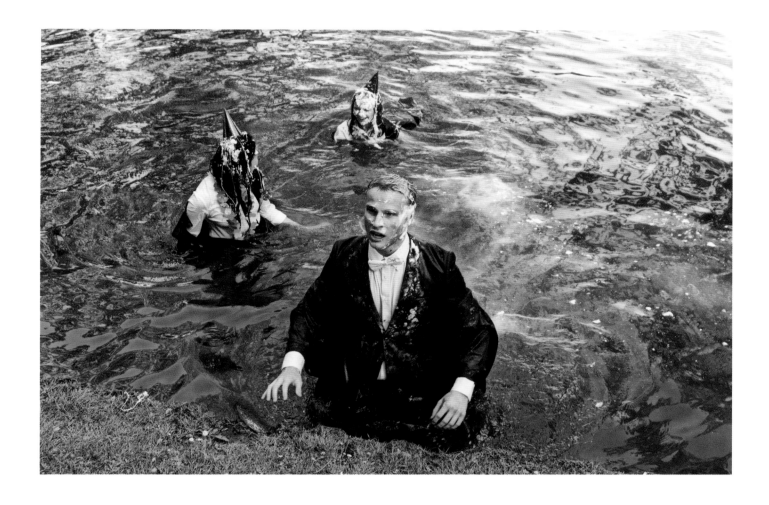

A dip in the River Cherwell. After trashing the tradition goes that you jump in the river, fully gowned. This was halted in the summer of 2016 when the gates to the river were locked by the university once trashing was over.

Trashing.

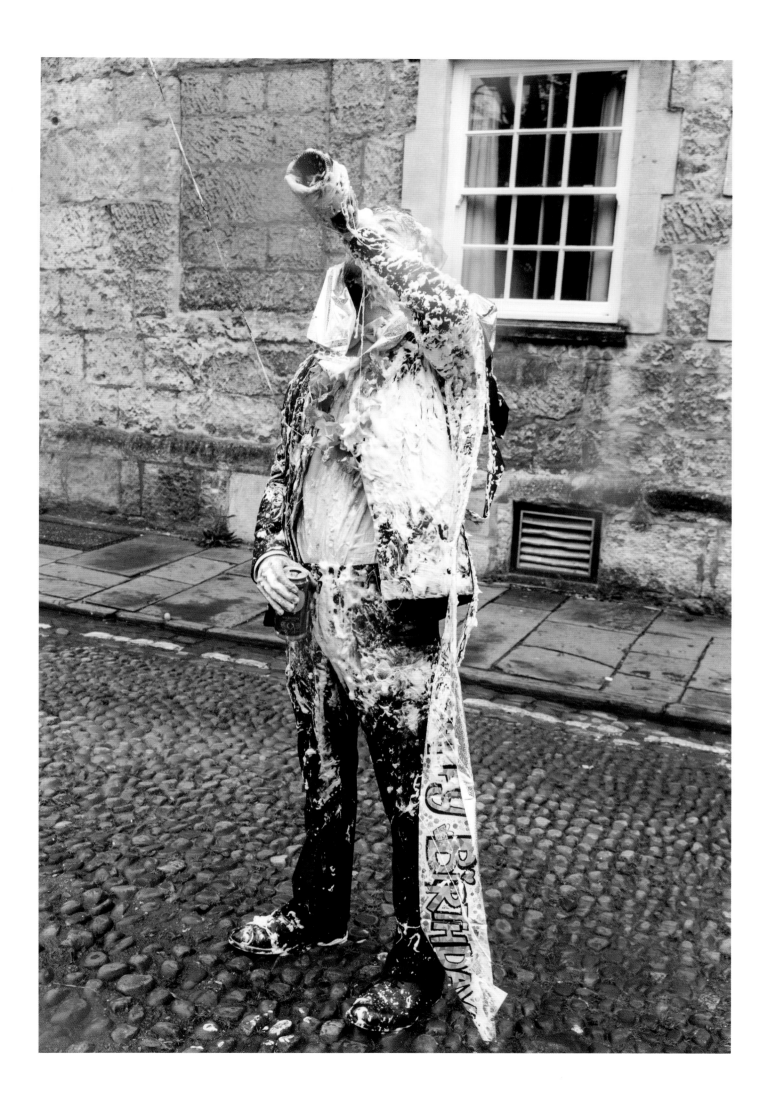

All dogs are banned from Oxford colleges, so this
dog, Jonah, with his owner, Wadham College chaplain
Wendy Wale, is actually called a cat.

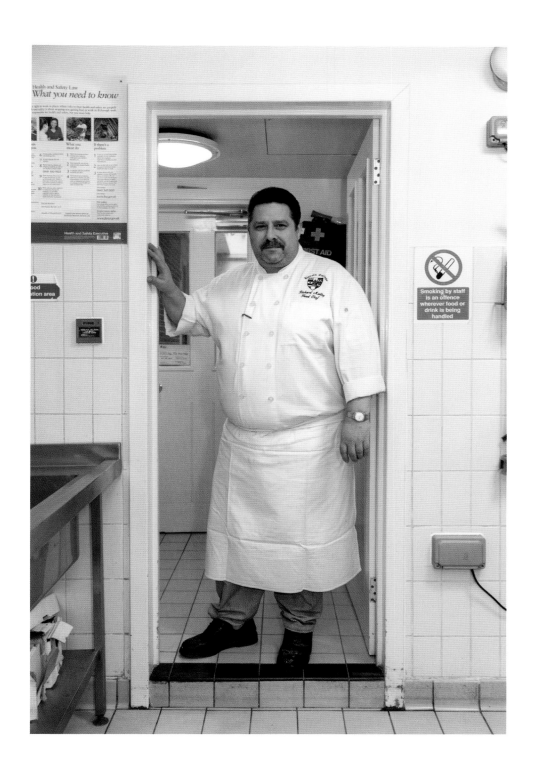

Richard Malloy, Chef, Lincoln College,
has been a chef for twenty years.

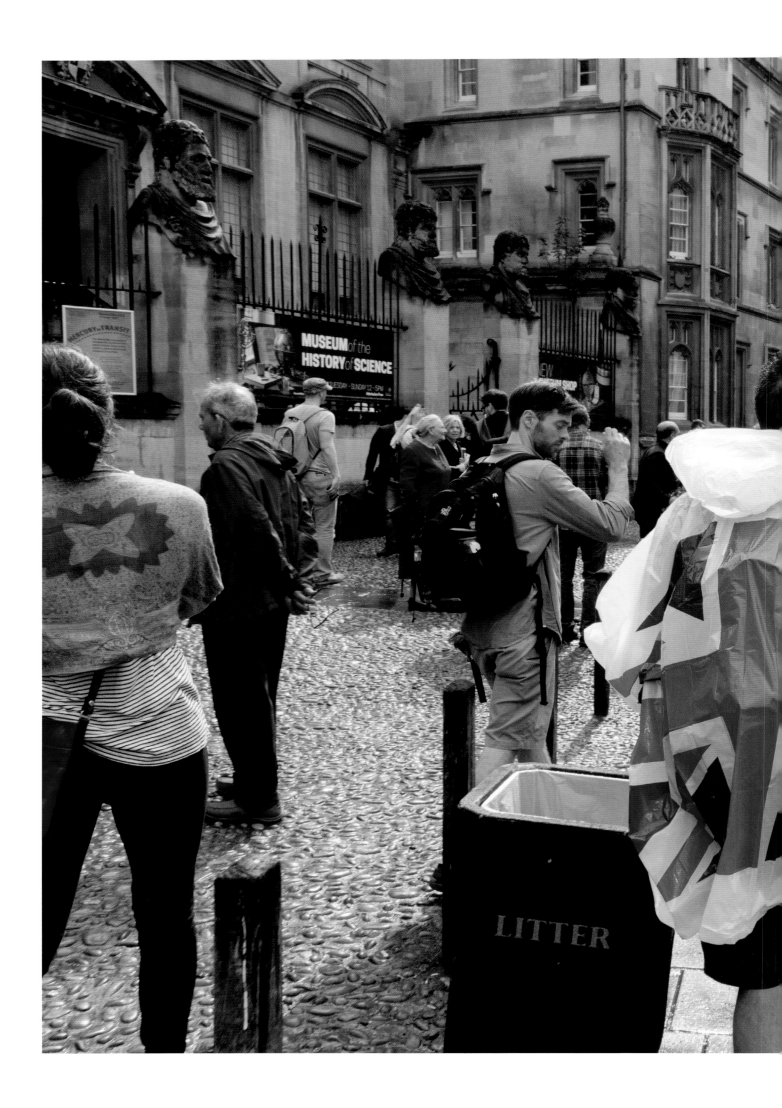

Open Day, Corpus Christi College.

Previous page Broad Street.

Following page Geoffrey Hill, Professor of Poetry (2010–15), in his box during Encaenia. Encaenia is the biggest formal occasion in the Oxford calendar. It is the day that honorary degrees are bestowed, in Latin, at the Sheldonian Theatre. In alternate years, the professor of poetry delivers the Crewian Oration.

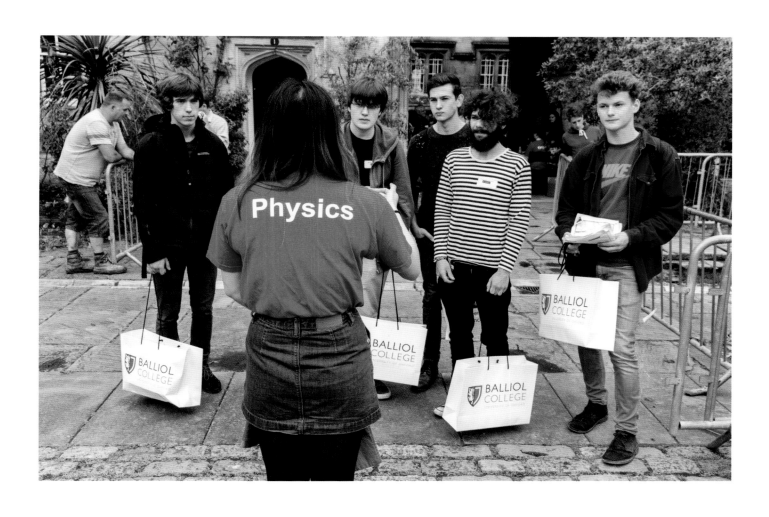

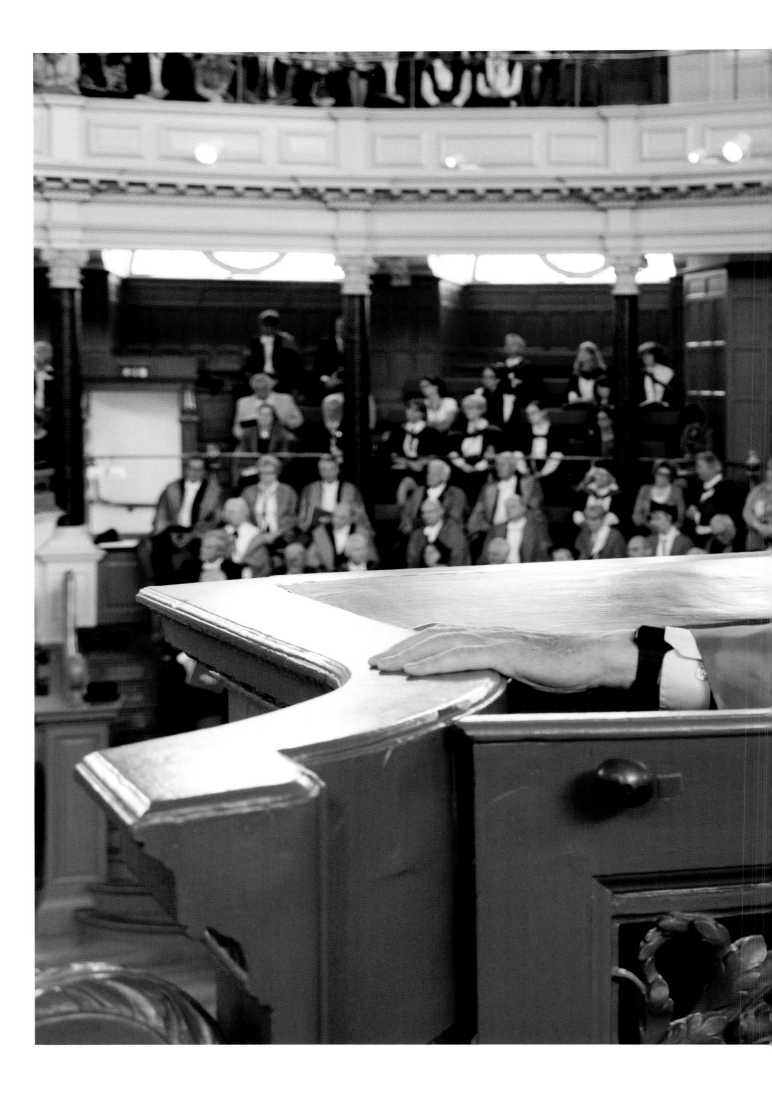

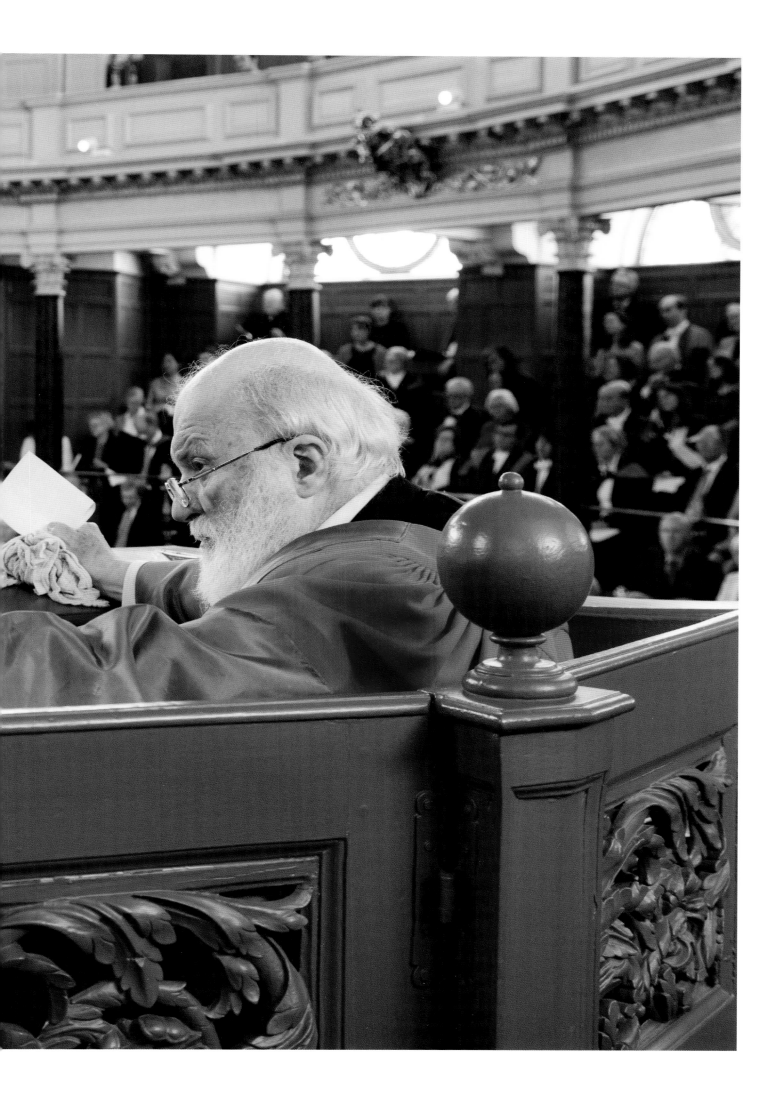

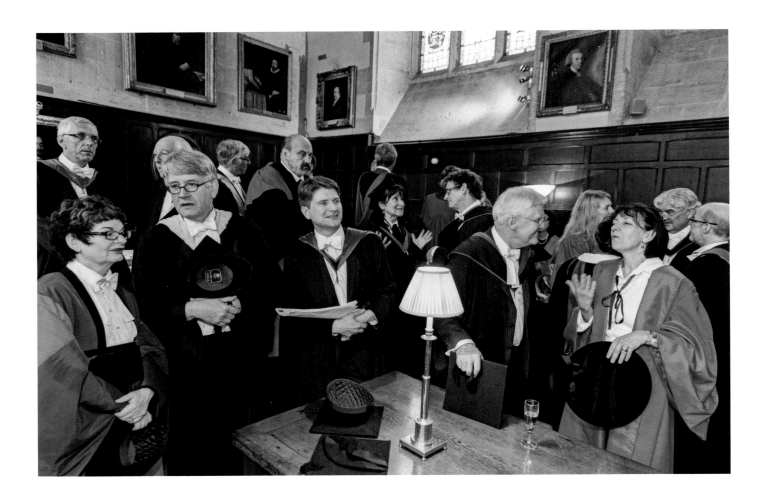

Assembled Encaenia guests linger in the Exeter College dining hall
before the main procession to partake of Lord Crewe's Benefaction,
named for a fund given to the university to supply champagne,
fresh strawberries, and peaches for the occasion.

Previous page Encaenia, Exeter College.

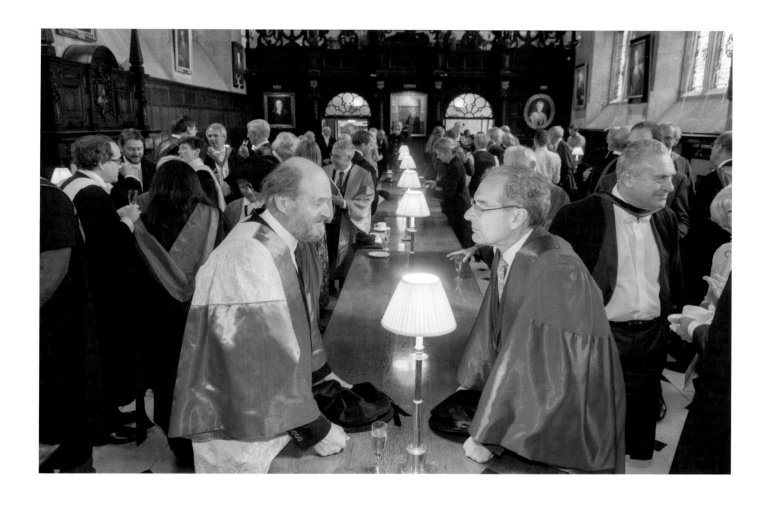

Encaenia, Exeter College.

Encaenia, the Old Schools Quadrangle, Bodleian Library.

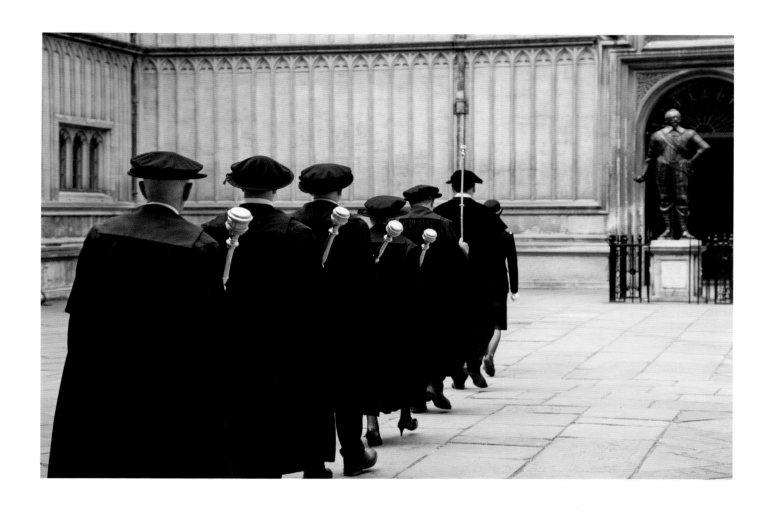

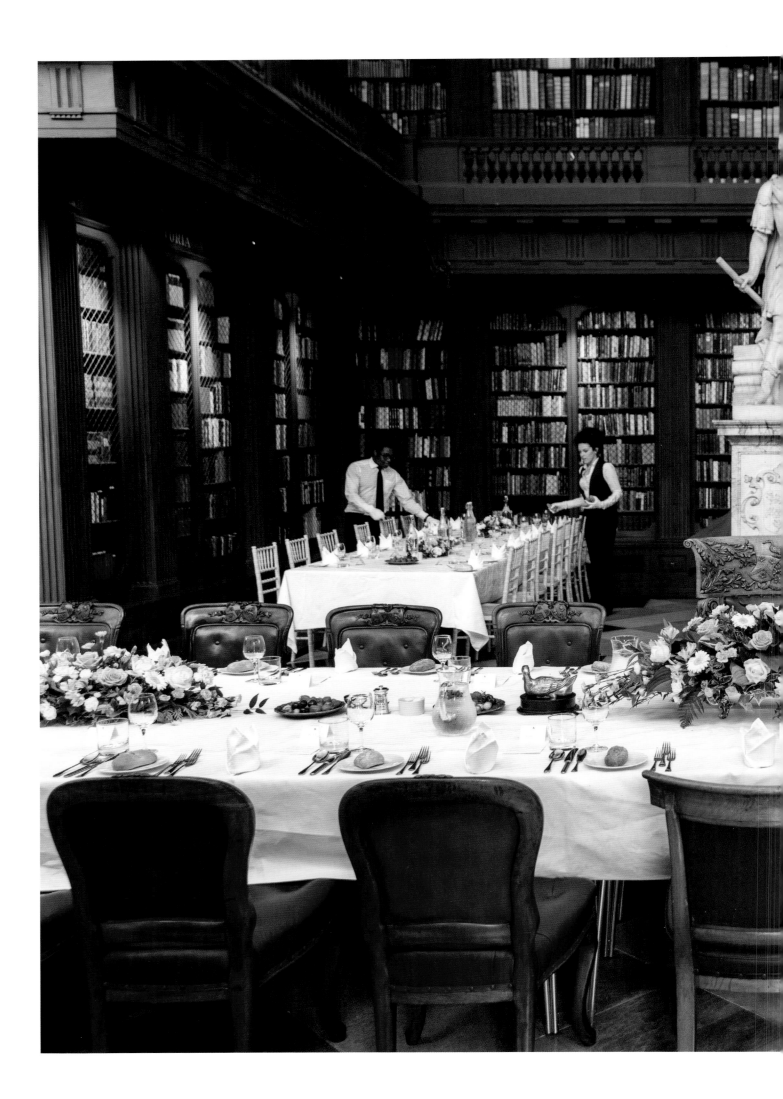

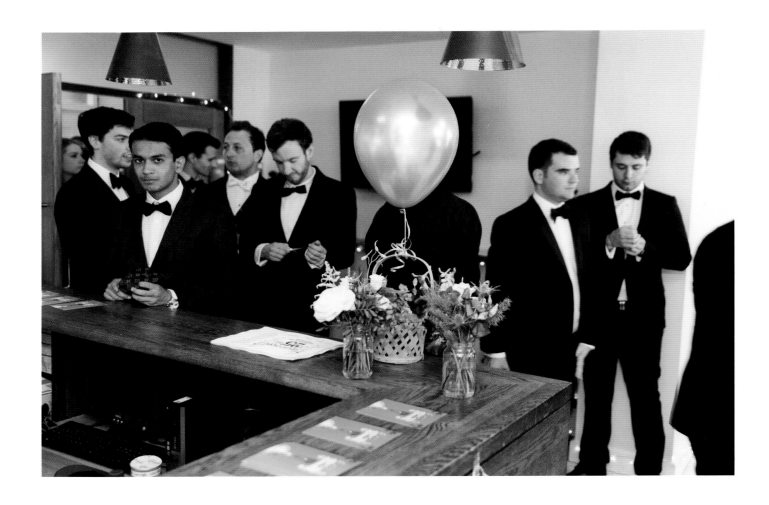

Kellogg College 25th Anniversary Ball.

Previous page Lunch for the guests attending Encaenia has been
held at All Souls College for over a hundred years, often in the
Codrington Library.

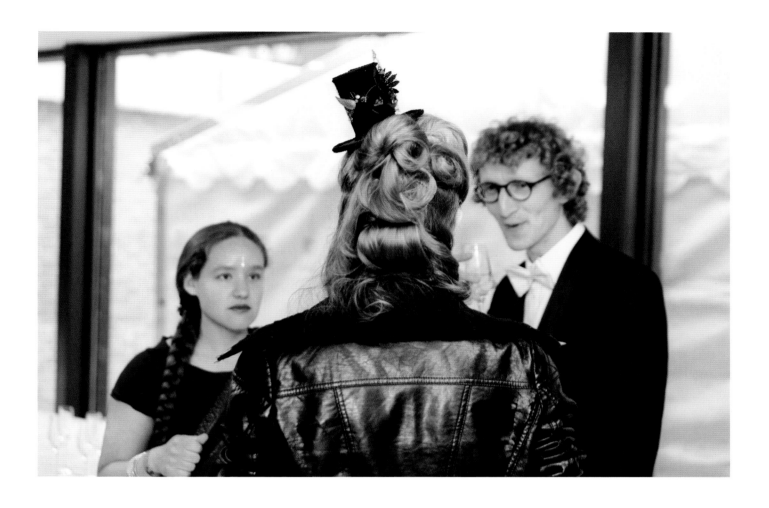

Kellogg College 25th Anniversary Ball.

Kellogg College 25th Anniversary Ball.

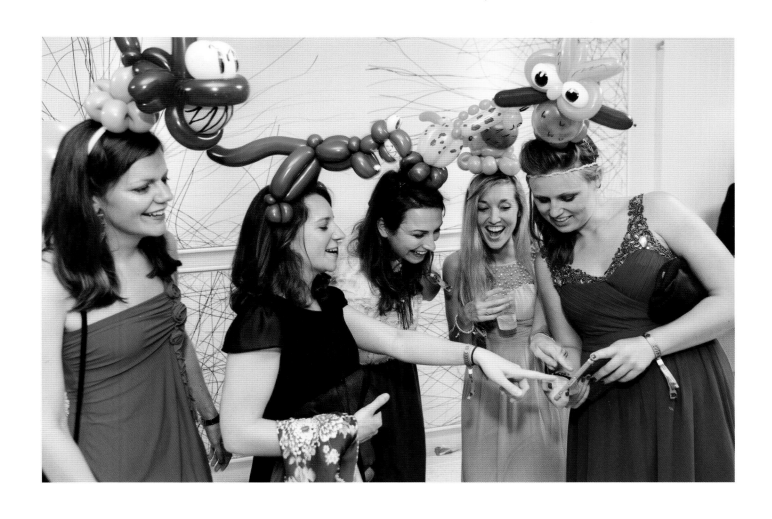

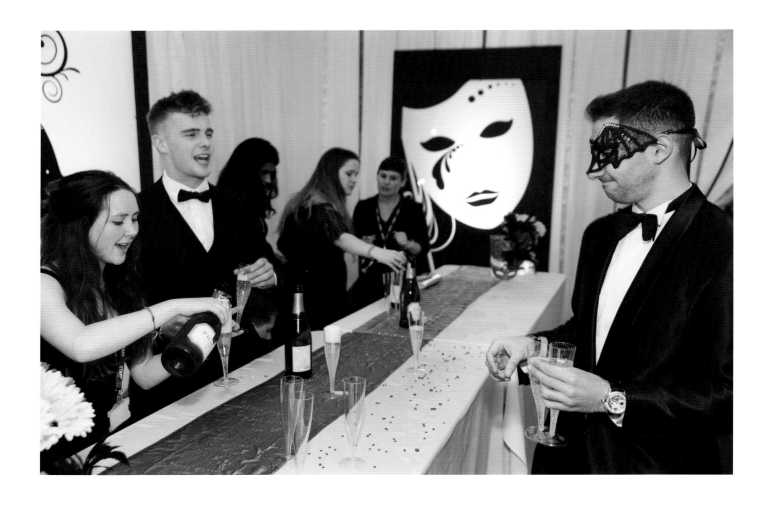

Lincoln College Ball.

Previous page Brasenose College Ball.

Somerville-Jesus College Ball.

Brasenose College Ball.

Brasenose College Ball.

Previous page Dodgems at Keble College Ball. Traditionally
a fairground ride is expected at all college balls. Swingboats,
helter-skelters, and dodgems are the most popular.

Kellogg College 25th Anniversary Ball.

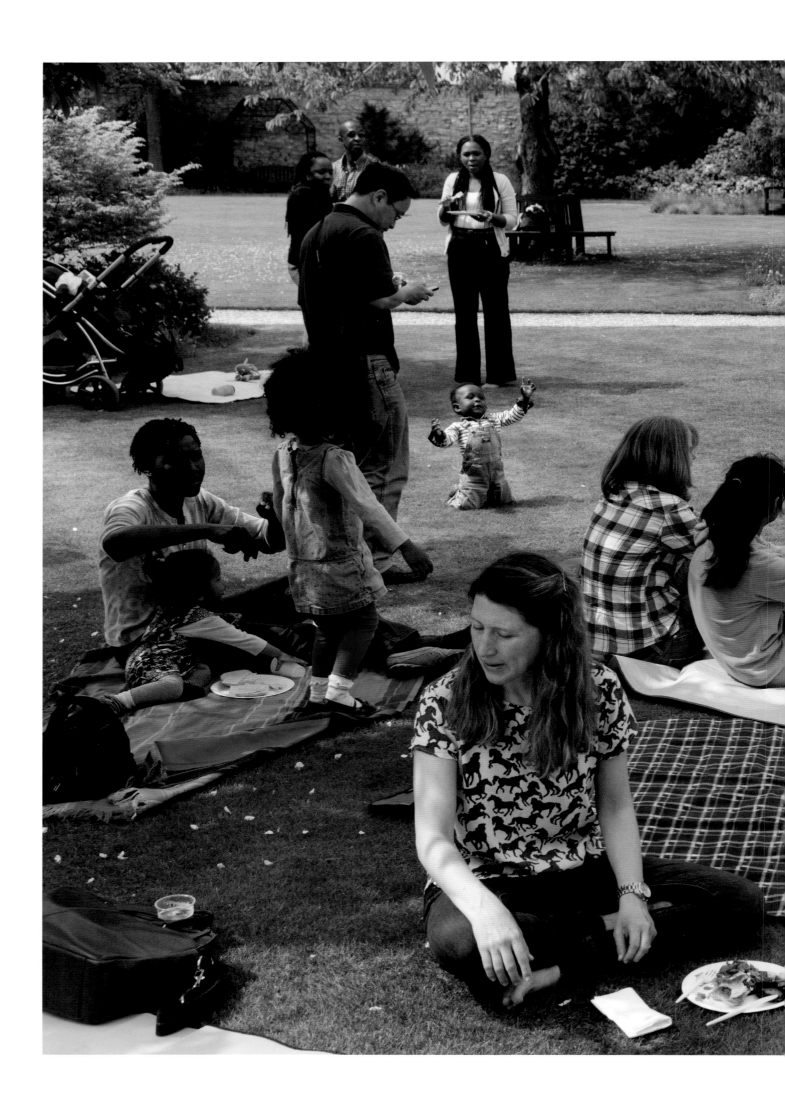

Summer Eights.

Previous page Summer garden party, Green Templeton College.

The Oxford Tolkien Society's 25th birthday
garden party, Christ Church.

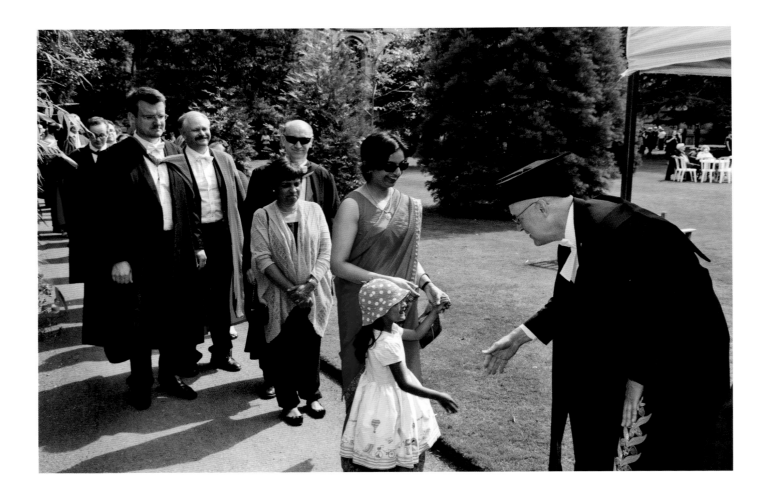

Meeting the vice-chancellor at the garden party
to celebrate Encaenia, Wadham College.

Encaenia garden party, All Souls College.

Encaenia garden party, Merton College.

Encaenia garden party, Merton College.

Lindsey Mills and Graham Hillsdon, the last two
remaining former bulldogs (college police, which were
disbanded in 2002), at the Encaenia garden party, Merton
College. Now known as proctor's officers and stripped
of their arresting powers, the officers' duties involve
stewarding at ceremonies, VIP visits, and exams.

Previous page Encaenia garden party, Wadham College.

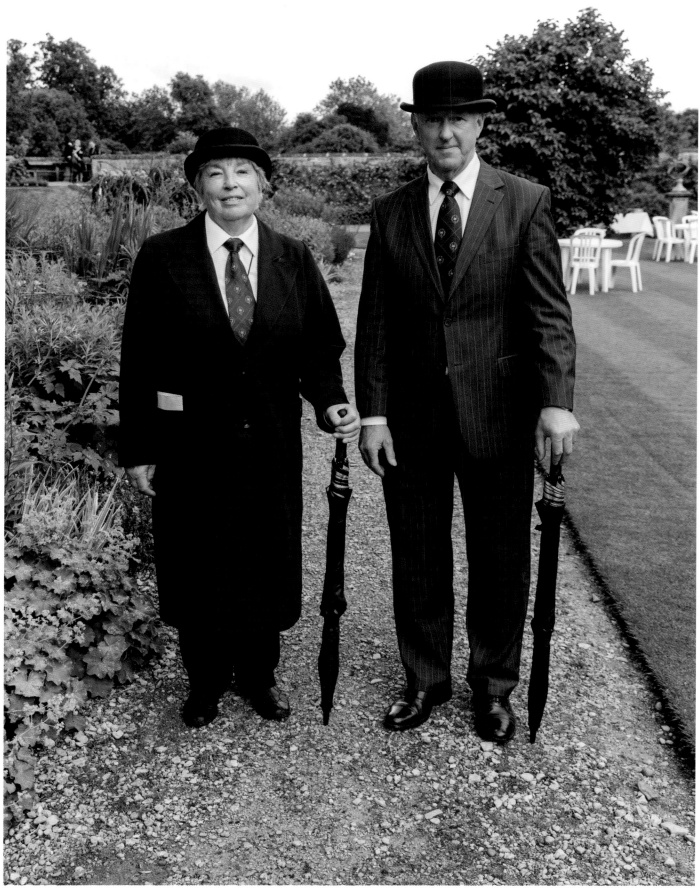

On the day of Encaenia, all guests are allowed to wear the academic dress denoting their highest achieving position. This is Sir John Elliott, Regius Professor Emeritus of Modern History, in his University of Barcelona gear, with his wife Lady Elliott.

Following page St Peter's College.

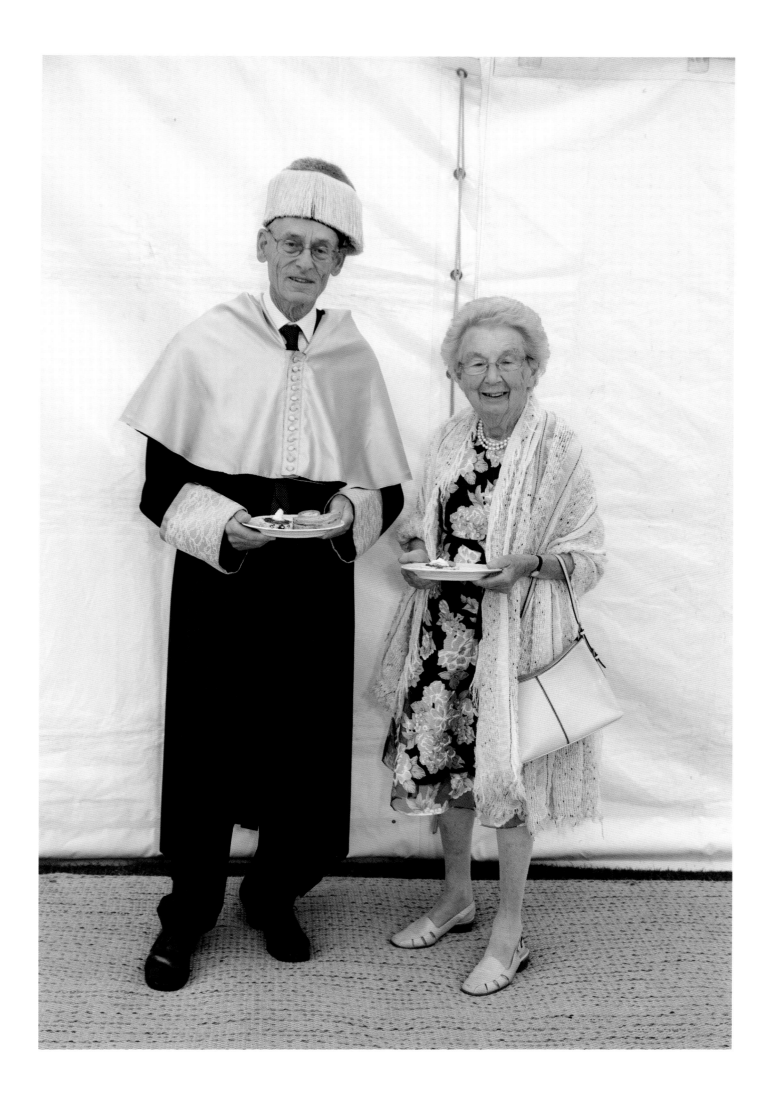

OXFORD

Oxford! The very word! Even back in my schooldays I knew of it—who didn't, after all? Back then I probably wasn't fully aware of its formal dictionary definition, which the *OED* says is lexical shorthand for 'the cultured or privileged lifestyle' associated with the great university. I perhaps only thought of Oxford to be a very special place indeed. Special and most probably unattainable, a place only to be imagined, to be revered from afar.

Except that one sunny but brisk January Wednesday in 1962, at the urging of a teacher who fancied I had a slight chance of winning a place to study my then hobby, geology, I found myself on a Great Western steam train from Dorset, bound for the city of my impossible dreams. I had been asked, on the basis of a laboriously composed and seemingly well-received letter, to sit the Oxford entrance examinations.

Much of what follows relates to my own affectionately held memories of half a century ago, a time in Oxford's long history when many of the mores and attitudes were somewhat different from those commonly held today. From my knowledge of later times—and I had a son who went up to Oxford in the late 1980s—I am aware of the subtly (but not entirely) altered condition of the place: I hope that my long-ago experiences, however, will seem to mesh to some fair extent with those of subsequent generations.

I'd like to say that my first impression of what John Keats had called *the finest city in the world* was of Elysian idyll, all high thinking and memorable architecture. But in fact the first thing to see back in those days, on stepping down from the train, was a crumbling blue-and-cream wooden warehouse of irredeemable and fly-postered ugliness—it was the former station, it turned out, a rusting iron-framed structure built when Oxford was the end of the London line—and which had since been replaced and turned into a depot piled with used motor tyres.

And it didn't get better as I plunged ever deeper into a red-brick warren of side streets that led, in convoluted fashion, past the tiny castle-like keep of Oxford Prison (then for only 120 prisoners; now a congeries of smart bistros and shops) and a scattering of cheap cafés and sawdust-floored pubs. There was, however, a pleasant and vaguely familiar aroma

all around. I was puzzled. A passer-by saw me sniff the air and she came up to me with a smile: 'Frank Cooper's factory,' she said in a rich country accent. 'Down on the Botley Road. Making marmalade. Every Wednesday they make marmalade. Tomorrow will be strawberry jam. Always strawberry on Thursdays.'

Eventually I reached what I imagined—from the gathering antiquity of the stonework—to be the vaguely defined outer limits of the university quarter itself. My map, with the colleges clustered in the city centre in black, showed that I was now walking beneath the old dirty grey limestone walls of Pembroke College, where I was to stay. I had applied from school for admission to a brand-new college, St Catherine's; but as the builders hadn't quite finished with it, Pembroke had offered rooms for the new applicants.

And now before me, as I turned a corner, was the real thing: my home for the next two nights, and by all appearances a classic of an Oxford college. There was a great wooden and iron-studded front gate, and inside it to the right a glassed-in porter's lodge, where a gravely chummy man wearing a black hat interrupted his chatting to look up my name in a leather-bound ledger, addressed me as *Mister* Winchester, and handed me a small bronze key.

As I passed inside the gate so the sound of traffic faded and I was promptly and protectively folded into a hushed world of ancient walled quadrangles and new-mown lawns and mullioned windows clouded by fronds of ivy. A clock obligingly chimed the quarter hour. A large marmalade cat, sunning itself on the stones, got up lazily and sauntered into an alleyway. An elderly man in a long black gown pointed me to an arched doorway off the main quad—Staircase Four, he said. Room Six, two flights up.

And that, I quickly learned, is how Oxford's lodgings are generally disposed. All the colleges have quadrangles—in some of the grander colleges (like the immense Christ Church over the road, or New College, further east) they can be vast and stadium-sized, while in more modestly scaled colleges like Pembroke they can be cosy, their antiquity more intimate than imposing. Off all the quads there are doorways, numbered entrances to staircases that lead to the rooms above; and on each floor there are two, sometimes three rooms. An oak noticeboard at the entrance offers a directory: dons—teaching members of the university, professors, and the like—are more generally to be found in larger rooms close to the ground, while more ordinary students are up high, not a few in the garrets, in the nosebleed section. Ground-floor rooms at Pembroke and others of the prettier colleges have windowboxes with gillyflowers or pinks—or in this winter season, early snowdrops and crocuses.

It is an Oxford peculiarity that each room has two entrance doors, one inside the other: the outer is generally kept open, to signal to neighbours and visitors that the occupant is within and potentially disturbable. But if both doors are closed—if the outer door, the *oak*, as the phrase has it, is *sported*, then whoever is inside is working, or for some other reason not to be reached.

Once through the two-door barrier I found my room to be monkishly severe—a table of dark teak, a bookcase of deal, a single iron bed, a handbasin, and a fireplace with a mantle,

which I would later learn would be the place to signify your social status, since a littering of invitation cards displayed atop it would indicate your popularity. But I was a temporary visitor: no pictures on the walls, no books on the shelves, no scattered clothes, certainly no invitations.

The examination was set for two o'clock. I was gazing anxiously out over the lawn below when there was a knock. It was another candidate, as nervous and awed as I was. I will call him Waring, he came from Wales, and his room was across the hall. It turned out that we were the only two taking the papers, he said. So at the appointed time we walked together down to the great hall, where a small group of men—including the elderly gent in the gown—were waiting, to invigilate. The pair of us were separated, Waring sitting at one end of the hall, beneath a portrait of Samuel Johnson, who had attended Pembroke (but hadn't graduated) back in the eighteenth century, me close to a picture of another old boy, James Smithson, who had famously gone on to fund the Smithsonian Institution in Washington.

A sheaf of writing paper, a clutch of pens, and one sheet of stiff cream foolscap, face down, lay on the table before me. One of the gowned men whispered to me that the examination would last for three hours, during which I would be asked to write essays, and to observe absolute silence while doing so. Was I ready? I nodded. The clock chimed the hour. A man sitting at High Table—elevated at one end of the hall, and where the college seniors usually dine—simply said, 'turn your papers over', and the exam began.

I remember there were five questions, and in the rubric above them just a pair of words: 'Answer two'. (Oxford examinations are famously spare in their instructions. A later young acquaintance of mine, a classicist known for his truly formidable intellect and linguistic chops, was once—so the story goes—presented with an examination consisting of a long passage from Horace and a simple one-word instruction: 'Translate'. This he did, but since there was no suggestion as to which language to translate into, and he wanted amusement, he rendered the Latin into Serbo-Croat. When a London language specialist was asked by the perplexed Oxford examiners who might best judge the quality of the translation they were told that only one man in the country had a sufficiently good knowledge of the two tongues—'a young man studying in Oxford, we believe . . .' The said young man was given, if grudgingly for his ostentation, a First.)

I answered my chosen two of the five questions, and remember them to this day, more than half a century later. Struggling through 'Two cheers for democracy—is two the right number?'—occupied my first ninety minutes; and by the time the clock rang five, signalling the end of the examination, I was putting the finishing touches to a second essay on the theme: 'Is the American way of life exportable?'

Waring and I, our fingers ink-stained and bruised with effort, then stumbled out into the cold. We ambled back to our rooms in the gathering winter gloom, gaslights illuminating the corners. 'Makes you think,' said a weary-looking Waring. He said he had chosen two entirely different essays, one on the Lingering Importance of the Enlightenment, the other

on Why We Should Prefer Black-and-White Films to those in Colour. 'Makes you think,' he repeated, bitterly. He didn't suppose he had done well. I didn't have any idea, though I had enjoyed the questions.

But whatever our fate, it was now sealed and we were free to go. I remember still every tiny detail of our remaining hours in the city.

Being January it was of course fully dark by the time we left our rooms. Dark and damply cold. We checked our watches when the great groaning bell boomed out from Tom Tower, above the entrance gate to Christ Church—checking them because the chimes for nine had rung out at five minutes *past* the hour, and we at first puzzled that our own watches might be wrong. But there turned out to be an explanation: the time-bells, and the subsequent curfew bell of 101 chimes—one for each of the original college students, plus one—are rung out each night at five minutes *after* the hour, a perverse piece of chronological pedantry that reminds all listeners that Oxford stands one degree and fifteen minutes of arc west of Greenwich, at 51.76°N, and more crucially for this fancy, 01.25°W. The bells sound the real solar Oxford time, and pointedly do not observe that artificial confection known as Greenwich Mean Time that had been foisted upon the university by the government down in London. (And *down* it is. Even though the railway convention across the entire rest of the country holds that trains to the capital leave from the 'up' platform, and it is the 'down' lines that take travellers away from London, quite the opposite is true for Oxford, uniquely so: one travels down to London from Oxford, and up to Oxford from London. So there.)

To get out of the cold we stopped at an ancient nearby coaching-inn called The Bear, first huddling by the fire, then crouching under the low and creaking ceilings of the old ostlers' quarters to examine some of the thousands of snipped-off ties which are ranged in glass cases along the walls. The jovial host behind the bar said that if my necktie wasn't in their collection I could have its tip snipped off and pinned to the wall in return for a pint of local beer; but after a diligent search he found that an earlier visitor—in 1926, a barely legible note said in sepia ink—had left his own, and so Waring and I had to hand over ready money for our pints, leaving little for a bun on the train journey home next day.

It snowed overnight, lightly. We took a long morning walk—first among the cattle on Christ Church Meadow and down to the banks of the Thames (or the Isis as it is known locally, a contraction of the Latin 'Tamesis'). We slip-slid on the frozen cobblestones of Merton Street, and risked a penny to climb the rickety stairs inside the tower of St Mary's Church on the High Street, around the alarmingly low-raftered belfry and out into the gallery below the spire, and a stiff cold breeze. From here we took in the magnificent view of the university's apparent epicentre surrounded by astonishments—the fragile spires of the Divinity School, the warm curving bulk of the Radcliffe Camera, the walls of the Fellows' Garden of Exeter College (atop which an elderly man was sitting on a bench, reading a newspaper), and the Sheldonian Theatre. In the private inner quadrangles of All Souls the lawns were sifted with snow, and lanterns glowed in the low light of winter morning from the windows of the

Codrington Library. Of course I couldn't identify any of those structures back in those days: they simply presented a bewildering wonderland of ancient loveliness.

A wonderland of which I wanted, keenly and even desperately, to be a part. Once Waring and I had gone our separate ways—we said our farewells and wished each other luck with a handshake on Reading station, he taking the express across to Cardiff and South Wales, me the slower train down to Bournemouth West and Dorchester—I took to thinking about the magical possibilities of becoming, eventually, a member of this ancient, beautiful university, of actually enjoying the cultured and privileged lifestyle to which the dictionary referred.

Dare I even hope, I wondered? Had my essays been good enough? Had they demonstrated that I might with effort be able to think with sufficient cogency and clarity to impress Oxford men and women—mainly men back then in the 1960s, it must be admitted—whose brains were so self-evidently among the best in the realm? I frankly doubted it, and confided so to the geography teacher back at school who had so generously shown his confidence in me. He told me not to worry. But I did fret, and as the days passed by, so my mood and esteem sank in lockstep. There was surely no chance.

Yet a month later a letter arrived from St Catherine's, from the dean of admissions, asking me to come for an interview. So there *was* a flicker of hope, still. The teacher smiled, knowingly. I got out my best suit—my only suit, I think, for my family was far from comfortably off—and pressed it myself. More recklessly I sent my whitest white shirt out to be laundered and its collar starched. I was much relieved that I hadn't handed over my tie to the landlord of The Bear, that it was still intact. I shined my shoes, then took the morning train back to Reading once again. It was late, and I made the clanking connection for Oxford with only seconds to spare. It was March, windy, dampishly cold.

By now the basic layout of the city was fairly familiar to me, and so I opted for walking the mile or so to St Catherine's. I passed the tyre depot without remark or disappointment, headed over the bridge across the limpid canal that went up to Banbury, noting with pleasure the catkins now in bloom and the daffodils shivering in the breeze. I walked past stately rows of maroon double-decker buses that waited for custom on Gloucester Green, then past the mid-Victorian Gothic pile of the Randolph Hotel with the more classically Ionic Ashmolean Museum opposite.

I hadn't been inside the Ashmolean before; but I vowed to do so if at all possible on this visit, because of one small and assuredly true story that had long charmed me. There was said to be in the music department a violin, a Stradivarius known as *Le Messie*. It had been gifted to the museum in 1939. The special feature of the instrument was that it had never once been played, and was kept in a glass case as an example of the maker's original art, undefiled by any use. One day an American, a keen and skilled musician from a southern state, arrived with the specific intent of playing this instrument for just a few precious moments—and when told this was impossible, that the violin was destined to remain in its virginal condition, burst into floods of uncontrollable tears.

The keeper of musical instruments, unused to such violent displays of emotion, took pity on the poor visitor. He unlocked the case and, looking around to make certain no one was watching, offered the violin to the teary man, leaving him in the room and shutting the door.

He reported afterwards hearing music wafting from within of a sweetness and rapturous beauty such as could only come from a man and an instrument wholly in love with one another. Once done with his aria or partita or opening notes of a sonata, so the man departed with expressions of gratitude, and *Le Messie* was replaced in its case; it has remained unplayed ever since.

But I hurried on past the museum, down Broad Street, past the entrance to Turl Street—the Broad, the High, the Turl, Oxford appends the definite article to so many of its street names—and into Holywell and the approaches to St Catherine's.

I had applied to this brand-new college in part because it was said to have a keen interest in students who wanted to study for a science degree—and geology, though in many senses a historical pursuit, was regarded very much as a science. I thought I might have a better chance at St Catherine's than at a college like Trinity or Balliol, which tended in those days to favour those wanting to follow politics or philosophy or the classics (the latter a branch of study formerly known as Greats, or before that, as Lit. Hum., short for *Literae Humaniores*—human literature, as distinct from *Literae Divinae*, the literature of God).

My chosen college had been created from the remains of St Catherine's Society, an elderly association that had long provided a gathering-place for the few hundred students who, for an assortment of reasons in the recent past, had no college at all. Its modest quarters—now transformed into the university's Faculty of Music—had been set down right next door to the city police station, and the society was not infrequently approached by the resident chief constable to see if it might supply some of its members to stand alongside criminal suspects in identification parades, in return for cups of tea.

But now it was to become a fully-fledged and *pukka* college, to house 400 members, and to stand at one with the almost forty other colleges that together make up the body known as Oxford University. With very few exceptions a student is nowadays obliged to be a member of a college: in each they are housed and fed and watered, while the university, in a general sense, offers them their education. It is rather more subtle and complex than that, as I shall describe later on: but for me back in 1962, walking down the hill on Manor Road, past the tiny chapel of St Cross, across a branch of the Cherwell River, and onto the almost-finished construction site, I knew St Catherine's only as the place into which I wished, above all else, to be welcomed as my home.

An elderly tutor in English, a Mr Horwood, had been deputed to assess my suitability, the cut of my jib. He was stooped, wore rubber kitchen gloves to cover up what he mumbled was 'some trouble with my hands', and asked me only three questions: did I go to the movies and if so why? And did I notice that down the corner of every room, no matter what colour the paint on its walls, there was a pale line, a near-absence of shade? Why might this be?

I glanced across to each of the corners of the small room in which we were sitting and yes, he was right: the walls were light blue but the corners each sported a line of white, hitherto barely noticeable and generally unnoticed.

But why? I had no idea, but mumbled what I thought might be two halfway sensible answers. First, perhaps the painter had been unable to get his brush fully into the corners, and so the hue or tint was necessarily more pale there than on the flat of the wall. Or else— and here I knew it was a stretch—I put it all down to the charges on the dust particles in the air which, I surmised, clung to the walls through static electricity. On the flat of the wall positively charged particles clung to a negatively charged wall. But at the corner the two charges cancelled each other out—here I was on very shaky ground—and so the dust refused to cling and fell into a small pile on the floor, Perhaps, if the vacuuming of the room had been carelessly done, we might find such a pile.

There was an awkward silence. I looked at my inquisitor, who was dreamily gazing out of the window. So what is the answer, I asked him. He started at my question. 'My gosh yes, I'm so sorry,' he replied with a thin smile. 'I honestly haven't the foggiest. I've been asking the same question of students who come here for the last fifty years, I think. It has always puzzled me, this wall thing, so I keep asking. Most people have pretty inventive answers. I rather liked yours.'

And then he added that I ought to be going, in order to catch my train home. So sweet of you to come. I do hope you'll have a nice journey.

Six weeks later and I was home in London, school having broken for Easter. My father brought a letter to me in my bedroom. It was in a brown envelope, the kind of envelope in which bills of small consequence arrived. It was from Oxford, and it looked as though it contained bad news—if good news, it surely would have been in an envelope of stiff cream paper, not this meagre thing.

I opened it with care, my father looking on anxiously. The letter was indeed from the college, from a man named Lloyd Stocken, tutor in biochemistry. *We are very pleased . . .* he began. I think I couldn't read the rest, my eyes were so clouded with tears. My father took it from my hands. It was a quick read. 'You're in!' he cried with delight. 'You've won a place at Oxford!'

* * *

The oldest university in the English-speaking world, it is claimed and generally believed. Certainly not as old as Bologna, the Holy Roman establishment of higher learning to which the Latin name *universitas* was first applied. And the University of Paris was older, too. But Oxford is certainly more ancient than Cambridge, is considerably senior to St Andrews and Glasgow and Aberdeen, and enjoys the same degree of veneration as Padua and Florence and Heidelberg and Salamanca and all those other great papally sanctioned institutions of European learning that came into being in the thirteenth and fourteenth centuries. Except

that some aver, probably mistakenly, that Oxford was actually born earlier than any of these *arrivistes*, and like to cite evidence for a greater antiquity that has long intrigued historians and champions of what has come to called the Oxford myth.

The home for all this instruction and intellect nestles in a broad and swampy valley between on the east side the chalk hills of the Chilterns—hills that keep the fleshpots and commercial vulgarities of London firmly at bay—and to the west the older Jurassic lime-stone uplands of the Cotswolds. It was originally—and to some extent it remains—a small and tidy market town that was first settled on a six-mile north-to-south trending moraine of gravel at the untidy and many-stranded junction of the rivers Thames and Cherwell. The gravel heap rises minimally—208 feet high at its centre—above a welter of soggy meadows where the oxen being driven to market might ford the shallows, hence (it is generally though maybe carelessly assumed) the city's name.

It is a town sited halfway, sort of, between the ports of London and Bristol. It is halfway, sort of, between Northampton and Southampton, between Bedford and Bath, between Gloucester and Reading. It is thus in terms of location—equidistant between the estuaries of the Thames, the Avon, and the Solent—and of demography a quintessentially southern English city, an unassailably middle English city. Which is perhaps why, considering its indelible association with England, more than a few romantically minded historians still today promote the notion that the founding of England's first formal seat of learning took place in AD 872, and that Oxford was born of the efforts of no less a distinguished and most essentially English Englishman than the cake-burning, Viking-repelling, and English-lan-guage-promoting monarch, King Alfred the Great.

This is the so-called Aluredian legend. It is a legend, hugely popular for many years, that turns out to have been based on a simple forgery that was perpetrated by the oldest college—named University College, naturally—to help win a fourteenth-century lawsuit. William Camden's monumental history *Britannia* included the story in its 1600 edition, widening its popularity. And it was reconfirmed by a thoughtlessly rendered court decision in London two centuries later. Its adherents almost built a gigantic statue of the king in the centre of Broad Street, and the myth did most certainly encourage the carving of scores of smaller royal depictions that were once dotted in niches and on pedestals all around the city.

But it was all piffle. There is no hard evidence whatsoever of King Alfred being involved in any way with the founding of Oxford University, and all of his depictions have now van-ished, save for a solitary bust in a church hall, beside St Mary's on the High Street. Nowadays the quite specific though meretricious claims made for King Alfred have been replaced by the vaguer but more truthful assertion that Oxford as a university shuffled into being some time after 1096 (when there is real evidence of someone being formally taught in town), gained strength when a clutch of English students fled home from Paris in 1167, was formally consolidated when the title of *chancellor* was bestowed on the head of the fledgling city

institution in 1214, and then finally properly coalesced itself around the documented gift by King Henry III of a royal charter in 1248. These are the key uncontested moments in the university's early life, and poor Alfred's association with it, though much wished for by English rhapsodists, lies buried in so much dust.

(The key moment for what is still genially known among Oxford types as 'the other place' somewhat echoes that part of the local origin story that involves students hurrying home from a hostile and probably xenophobic Paris. In 1209 there was an outbreak of hostility in Oxford—a murder! some hangings!—between young students and local inhabitants who felt displaced and alienated. The resulting brouhaha prompted a clutch of the less robust Oxford men to abandon the city and head eastward, eventually settling their books and their easels down in the more peaceable fenlands beside the river Cam, in Cambridge.)

The university is one thing, the colleges quite another, their sum and combination making for an institution of bewildering complexity. *Universitas Oxoniensis*, formally known in English (though Latin is everywhere, still often spoken today and very often written) by the title *The Chancellor, Masters, and Scholars of the University of Oxford*, is a daunting beast indeed, as my years there were to endlessly confirm and reconfirm.

There is, for example, no particular building to which one can point, say for the benefit of a visiting tourist, and declare it to be The University. There is a ruling body, though, known as Congregation, and back in my time a smaller group known as the Hebdomadal Council which met, as its name implied, weekly. (It has since been replaced by the rather dull-sounding University Council.) Additionally there exists an enormous assembly called Convocation, to which every graduate of the university belongs, wherever they may currently live. Convocation wields the authority to elect the chancellor and the professor of poetry, but not much more.

There are university boards and committees and referees and trustees aplenty. And there are of course the departments and schools and institutes (of geography, classics, ornithology, philosophy, pharmacology, American studies, and countless other disciplines), there are offices (such as the University Chest, where the monies are counted), there are faculties and museums and laboratories and libraries, scores of libraries, which are mostly owned and operated, as it were, by the university.

There are functionaries, too, men and women whose salaries are paid by the university—from daunting figures like the appointed-for-life chancellor (who has a robe with gold embroidered sleeves and long black train, and with a pageboy in constant attendance to hold it up on formal occasions), to the now seven-year-term office holder of vice-chancellor, who was formerly selected to serve for two years from the colleges on rotation. There are much-feared disciplinarians like the proctors, who maintain public order and until recently ran a small police force, just a quartet of burly and be-bowlered men known as bulldogs (who would respectfully collar and then challenge suspected miscreants with the studiously polite but very firm 'Are you a member of this university? Name and college, please?'—an

enquiry that promises trouble to follow—a fine, rustication, or the most extreme disbenefit, an order to be 'sent down').

And there are charmingly risible ceremonial officials like the bedels and the public orator, the latter a scholar able to speak Latin with what is supposed to be the accent used in Cicero's time, and whose duties include employing this skill to offer up formal speeches to the uncomprehending multitudes who attend the university's grand public events.

But it is the colleges that in reality—mostly old, venerable, and architecturally very beautiful realities—make up the university, and they do so by being both within it and without it all at once, each part of something and aloof from it all, like Schrödinger's cat sculpted (mostly) in faded blond Cotswold stone. Perhaps the best way of seeing the university is as a federation of these colleges—each one of them private, each acting with benefit of its own royal blessings and rules and ceremonies, each with its own ways of doing things. The university awards the degrees at the end of each undergraduate's progress; but it is the colleges that direct how he or she makes that progress. So here, rather than write of the theory of the thing, kindly follow me as I recount as best I can my own progress through the three years of attendance at St Catherine's College between the autumn of 1963 and the high summer of 1966. Some matters will have altered in the decades since, but not by much. And I will endeavour to illustrate where and when they have.

* * *

A small illustration of how little Oxford changes, of how creakily it alters when it tries to—and of yet how its central magic remains perpetually undisturbed—presented itself recently, just after the June solstice of 2016.

Midsummer is the time of Encaenia, the Greek-originated ceremony of annual renewal that provides the greatest public demonstration of this university in full fig and on parade. It is all very formal, is performed with serious high purpose by attendees all swathed in gowns and robes and liripipes of gaudy technicolour. These worthies—professors, heads of college, lecturers, university officials—all first assemble and kit themselves out in their various items of owned or rented-for-the-day clothing, then process in double file to enter Christopher Wren's Sheldonian Theatre (designed when the architect was barely 30) to either declaim or listen to soliloquies in ancient tongues, then applaud the awarding of degrees to a select crop of distinguished honorands, and finally dine privately with great extravagance, with the unlacing of shoes and stays and exhalations of general exhausted relief.

In 2016 the Encaenia assembly took place in the hall of Exeter College, a classically venerable college (founded in 1314) and set down just to the west of the Bodleian Library, right in the heart of things. Maybe fifty to sixty of the university high panjandrums, their academic robes peacock displays of scarlets and purples, were crammed into the hall, the eight bewildered outsiders who were to be given degrees (one of them the man who designed the iPhone, another a Spanish film director of stellar repute, then a serious-looking

Nobel-winning economist) being shepherded around by bedels, their university-supplied and black-uniformed chaperones.

Before the ceremony they were all to enjoy—*partake* was probably the word of the original gift—what is known as Lord Crewe's Benefaction, his lordship being a seventeenth-century bishop of Oxford who had left money in 1721 to help jolly along this otherwise rather daunting ceremony. His intended benefaction was simple, and yet nicely appropriate for the warmth of a summer's morning: all members present were to partake, and in perpetuity, a cluster of strawberries and peaches, and a glass of good champagne.

Once everyone was in the room so Lord Patten, the chancellor (with his page doing his best to keep up, supporting the black damask silk train while the former governor of Hong Kong and one-time chairman of the BBC bulldozed around the room greeting old friends) gave the signal that all was ready. A squadron of waiters appeared noiselessly from the walls and wafted through the room, the men with glasses of champagne, the waitresses with trays of tiny pastry shells glistening with tempting piles of fruit.

And it is here that Oxford showed its ability to alter, and yet not to change at all.

It would most certainly continue to feed its members champagne early on a summer's day, just as the lordly bishop had ordained 300 years before. But as for the pastry shells of strawberries and peaches—well, modernity beckons. This year each of the waitresses was commanded to whisper with a smile as she offered the Benefaction that 'a *gluten-free* alternative is available'.

A puzzled Lord Crewe, I imagined, would have thought the alteration really most peculiar.

* * *

My parents, beaming with pride, drove me up to Oxford on a drizzling October Sunday in 1963. St Catherine's, my chosen college, was still something of a wreck, a work in progress.

Arne Jacobsen, a Danish architect, had been selected (to the chagrin of British architects, who felt much disdained) to design and build what would be the first wholly new Oxford undergraduate college for fifty years. It had opened the year before, still then a building site, and the first clutch of students—all of them men, though in 1974 the college became one of the first to admit women—were known as the 'Dirty Thirty', since so much glutinous mud abounded. It wasn't quite so bad when I came up a year later, though gumboots were still recommended.

I was shown to my brand-new room—staircase 13, room 18, on the first floor overlooking the quadrangle. Waiting for me at the door was a lugubrious man named Eric who explained in tones of weary kindliness that he was to be my scout—and that he would endeavour to look after me for as many years as I lived in college.

This I found at first well-nigh incredible. A scout (the name dates from at least 1708) was, in essence, a servant—a calling that, for a youngster like me brought up in respectable impoverishment in a Dorset village, was utterly unfamiliar. I had read one Victorian account

of the duties performed by such heroic men, and so I knew vaguely what to expect. As one George Coleman the Younger wrote in 1830:

Your Scout is not an animal remarkable for sloth and when he considers the quantity of work he has to slur over, with small pay, among his multitude of masters, it serves, perhaps, a salve to his conscience for his petty larcenies. He undergoes the special toil of Boots at a well-frequented inn, and a Waiter at Vaux-hall, in a successful season—After coat-brushing, shoe-cleaning and message-running in the morning, he has, upon average, a dozen supper-parties to attend in the same night and at the same hour—shifting a plate here, drawing a cork there—running to and fro, from one set of chambers to another—and almost solving the Irishman's question of 'how can I be in two places at once, unless I was a bird?'

Was this still true, I asked Eric—who had come in specially on a Sunday to introduce himself, which I thought was most polite. What duties did he care to perform? Were they all of those mentioned in what I remembered of Coleman's essay? 'Brushing and cleaning most certainly,' he replied. 'And I can clear away after parties. But do go easy on me sir,' he replied. 'I am getting a little on in years. That is all I ask.'

And for all the years I had Eric by my side, I certainly did 'go easy' on him indeed—though by today's standards, it doesn't sound easy at all. He would take my shoes last thing at night, and return them shined in the morning, along with a pot of tea, the weather forecast for the day, and such news as he had learned from the morning radio. As he placed the tea-tray beside me he would also announce the time, and within a few days of my arrival learned sufficient of my lecture schedule to advise me when it was necessary for me to get up, when to dress, when to leave. He was a fount of advice more generally: I recall that in the first bewildered week he instructed me, for instance, on the wisdom of giving tea parties—the best and least costly way of making new friends. In that spirit told me where to buy an inexpensive toaster and an electric kettle. 'Black cherry jam', he added with a conspiratorial grin, 'is a particular favourite of the ladies.'

Today's undergraduates are rather more uneasy with the notion of college servants—whether the scouts of Oxford or the bedders, all women, who perform similar duties across in Cambridge. One modern student writing in a London newspaper described herself as 'mortified' to discover that 'another human being would be expected to clean up after me' during her time at university, and vowed to tidy her own room instead so that her scout would occupy his time with conversation rather than cleaning. Yet the tradition persists, maintaining the idea of Oxford as a bubble of intellectual and social privilege. It remains a place 'where life is mental', as the nineteenth-century poet Robert Montgomery had it, 'and the world forgot!'

For the improvement of *my* mental life, such as it was, I had come up to Oxford to study geology. It perhaps bears repeating that the founding principle of St Catherine's founder was a determination to have in the college as many science undergraduates as those studying the liberal arts, which is why I had thought, correctly as it happened, that I might have some

chance of acceptance. And so my first university chore on that first day—as opposed to my first college chore, which was meeting Eric and having him help me unpack and sort out my room—was to find the geology department and to work out the mechanics of just how I was going to be educated, Oxford-style, in the mysterious business of rocks.

* * *

It all began on Monday, the first day of what is known as Full Term. The weeks in Oxford are numbered, and referred to by these numbers in most conversations. This, of course, was First Week. First Week of Michaelmas Term. (Hilary Term comes after Christmas. Trinity Term begins in April.) Each of the Full Terms—the periods when teaching occurs, when the undergraduates are in place—lasts for just eight weeks. Many of the events of social, athletic, and academic importance tend to take place in Fifth Week. Most of us would go back to our homes at the end of Eighth Week.

This first Monday it took maybe an easy fifteen minutes for me to walk from college: one straight walk between rugby fields and roped-off cricket pitches, a left turn along South Parks Road (the alluring glimpse of the immense abundance of the University Parks through a set of iron gates beyond), then past various laboratories and science libraries and departments of inorganic and organic chemistry. Fittingly for this cluster of science-related buildings there was also one of the then tallest Oxford structures, the headquarters for biochemistry. Height was not its most notable feature, though: this was a building which notoriously sported a paternoster lift, a continuously slow-moving and doorless elevator into and out of which you stepped as it rose and fell between floors. But occasionally people got trapped, or fell, and were hurt, some seriously, and so the paternoster—the lift so-called because each loop of cars resembled a string of rosary beads—was abandoned around the world, with just Oxford (and a handful of German cities) housing the last holdouts. It has altogether gone from Oxford now.

Geology has been taught in Oxford since almost the very inception of the science. The Reverend William Buckland was made the calling's first reader in 1818—and though his geological knowledge was prodigious for the time, it is his reputation for adventurous dietary eccentricity that marks his memory today. He was fascinated by living creatures of every stripe; but though he was well-enough disposed toward them while they were alive, he also vowed to try to eat his way through the entire animal kingdom during his lifetime.

He once said the worst thing he had ever tasted was mole, but added later that he thought bluebottle equally disagreeable. He served guests with baked crocodile, horse, and mice swirled in batter. He had a particularly alarming menagerie in his rooms at Corpus Christi College, where he had previously taken Holy Orders: where others might have a cat, a dog, or a cavy, Buckland possessed a bear, which wandered freely through his suite, a pair of fly-eating lizards, and a jackal, which was sensibly restrained in the Fellows' Garden, and was once heard underneath a sofa, noisily crunching up a brace of guinea-pigs for its dinner.

Buckland's knowledge of animal anatomy was unrivalled, and it frequently led to a scepticism and curiosity which offended a variety of myth-makers. He once declared the sacred bones of St Rosalia in Palermo to be in fact those of a long-dead goat, and in another continental church fell to the floor to lick and taste the supposed blood of a saint that had been found dripping from his tomb, only to pronounce that it was actually the urine of a bat. Once in the Oxfordshire village of Nuneham he was shown a precious silver case that allegedly held the heart of a French king and insisted after inspection, and to the alarm of its owner, on swallowing it whole.

* * *

By the 1960s the successor department to that in which Dean Buckland had worked was housed (but has since been re-sited once more, mingled with aspects of metallurgy and horridly renamed 'Earth Sciences') in a modest structure built after the Second World War, its floors of Ordovician slate and Cretaceous marble, its walls decorated with Jurassic oolite. It stood beside where the very earliest professors had once held sway, in the immense and unashamedly Gothic-themed University Museum.

This was a building, constructed at vast cost in 1860, on which that great champion of all things Gothic, the artist John Ruskin, had briefly laboured in person (he constructed one of the interior pillars, but so ineptly that it had to be knocked down and rebuilt). It was connected to my newer geology building by a narrow, fossil-filled corridor. Some few of our lecturers—I remember Kenneth Sandford, an expert on both the glaciation of the High Arctic and the physics of Saharan sand dunes—were lucky enough to be still quartered in vast museum offices, beneath the elegant traceries of iron girders and the glass-paned roof.

Though many loathed the old building, I adored it; and at every break between lectures, especially if it was drizzling a typical Oxford drizzle, I would scuttle down the short corridor of Carboniferous ferns and pyritized brachiopods to wander along its rows, and to peer down at some special example of an ammonite or a *Megatherium*, shielding my eyes from the sky's window-glare (even on sunless days, so much glass had been used in the roof) by using a specially made small plywood baffle, of which clusters were obligingly left on top of the specimen cases.

The museum is famed for many reasons—in thinking circles perhaps most of all for housing, soon after its 1860 opening, the debate (memorialized by a handsome plaque) which reputedly settled the matter of evolution once and for all.

Thomas Huxley, a tall and slender and somewhat nervously disposed 35-year-old biologist, 'black-eyed and with a lightning intellect', happened to be Charles Darwin's champion on that long-remembered June evening. The tub-thumping rhetorician and pompously fundamentalist Church of England Bishop of Oxford, Samuel Wilberforce, for whom the whole farrago of Darwinian evolution (*The Origin of Species* had been published only the previous year) was the purest fiction, was his opponent. Crowds had gathered: so eager to

witness the encounter were the attendees of that year's meeting of the British Association for the Advancement of Science—an annual gathering that was seldom dull, with profound new discoveries being announced with regularity—that the debate had to be moved from a cramped lecture hall into the University Museum's more capacious library.

'Soapy Sam' Wilberforce—so named because Disraeli had once described his manner as 'unctuous, oleaginous, saponaceous'—rose first to make the churchly case against evolution, to set out his case against the horrendous notion that mankind might have descended from chimpanzees. He rumbled on for many minutes about the cheek of it all before, with a sly and withering sarcasm, he asked of the young Huxley sitting before him whether he claimed his own inheritance from the apes 'through his grandfather or his grandmother'. The audience laughed bitterly at the joke, imagining Sam had struck home, had got the better of the upstart.

Far from it. Huxley's reported response (though there are many versions) was in the best traditions of Oxford repartee, and it stunned. 'I am not in the least bit ashamed to have a monkey as an ancestor,' he said, and paused for effect. Then, his argument attaining a soaring climax: 'But I would be ashamed to be connected with a man who used his great gifts to obscure the truth—a man who, not content with an equivocal success in his own sphere of activity, plunges into scientific questions with which he has no real acquaintance, only to obscure them by an aimless rhetoric.'

Huxley had spoken without a script. The audience was too stupefied to react with other than silence. So devastating and humiliating was his attack on the great bishop said to be—back then bishops were quite literally sacrosanct, untouchable representatives of the deity—that one Lady Brewer promptly fainted and had to be revived with draughts of sal volatile. Wilberforce was mortally wounded; he eventually quit Oxford to become Bishop of Winchester, his reputation tainted among most for the remaining thirteen years of his life.

There was one other reason, rather less significant but rather more poignantly charming, for my coming to so love the University Museum, to savour the prospect of being so close.

For the museum is where one particularly sorry collection is kept, of a few small bones, fragments of skull, and magnificent beak, of the world's very last dodo. I found them on my first visit, in a glass case that had been removed there a century before from the Ashmolean Museum, where the near-virgin violin, previously mentioned, remains.

An almost entire specimen of the bird once resided in a bizarre London-based collection known as the Tradescant Collection of Rarities. It had been originally brought up and across from Mauritius and labelled as being 'A Dodar . . . it is not able to flie being so big'. But over the years it rotted and started to smell. A heartless curator ordered it thrown out and burned, all that was left being the creature's noble beak and its right foot. Affronted biologists promptly rebuilt it, with bones from other birds and, it was said, the upper portion of the head of a vulture.

By the time it came to be housed in the University Museum it was disassembled once again by enraged biological purists. This time they drew what they supposed to be a dodoic outline

and placed its only remaining relic bits and pieces in their appropriate locations on the drawing, as if they were reconstructing a murder-scene. And thus it remains today—proving itself a beloved Oxford inspiration for many, and most prominently that most Oxford-original writer-mathematician, then pen-named Lewis Carroll.

This shy, half-deaf, and invariably stammering Christ Church scholar, a pioneer photographer with an abiding friendship with the very young daughter of the college dean, happily found that his own true name, Charles Dodgson, placed him right beside the dodo in the *Encyclopaedia Britannica*. This, he said, had amplified his own intimacy with the great bird. (When he stuttered he often announced his name as Do-do-Dodgson.) It also encouraged his employment of the dodo bird as a motif of one of Oxford's most marvellously Oxford books, a magical story which he first related to that 10-year-old child and her siblings on a glorious summer's river outing, and which was famously published in 1865 as *Alice's Adventures in Wonderland*.

All of these wonders and a thousand more—for the University Museum houses another even more remarkable museum within itself, entry being gained through a small door in the rear wall as if you were in a Chicago speakeasy; more details later—all these were within a minute's sheltered stroll of my department.

And what a history the department had! There was no doubt that I had chosen my course of study very well: surely no other discipline at the university offered so much treasure on its very doorstep. I felt it was indeed true serendipity—a phenomenon with which this ancient place was abundantly supplied.

* * *

Stephen Leacock, a Canadian writer of amusing savagery, once tore royally into Oxford's style of teaching. 'Its methods are antiquated,' he wrote in 1922 in his locally popular *My Discovery of England*. 'It despises science. Its lectures are rotten. It has professors who never teach and students who never learn. It has no order, no arrangement, no system. Its curriculum is unintelligible. It has no president. It has no state legislature to tell it how to teach and yet—*it gets there*. Whether we like it or not Oxford gives something to its students, a life and a mode of thought, which in America as yet we can emulate but not equal . . .'

I had spent a while across in Canada in the year before 'going up' (this being the preferred form of words to signify beginning study at Oxford), and not a few friends had already read to me from Leacock's peroration. So I wondered how it would be, what the teaching would truly be like. I wondered—fretted, even—at my becoming part of the tutorial system, the system which forms then and still forms today the basis of all teaching at the university.

My tutor, Harold Reading, was there to welcome me. He was in his forties—tall, slender, and very fit, with spectacles and tweeds and the leather-skinned look of a man who spent much of his time outside. There were only eight students reading geology that year—it was far from a popular field of study—and he was tutor to just two of us.

He was by calling a stratigrapher, a scholar mainly interested in the manner in which sedimentary rocks, limestones, sandstones, shales, were laid down. His study presented a field geologist's heaven, a room crammed with books and rolled-up and spread-out maps and charts, and with fossils used as paperweights and suites of drawers filled with rock samples. The floor was littered with pairs of hobnailed boots, there were old rucksacks and walking sticks and clusters of well-worn Estwing geological hammers, magnifying glasses, small bottles of hydrochloric acid. His room looked like the planning HQ for a man eternally ready to leave on an expedition to some waterless plain or steep-sided canyon where a new fossil or a fault was waiting to be found and mapped and described.

He riffled through the papers which offered the Michaelmas Term lecture schedule—none of them compulsory, as was then true of all Oxford lectures, no matter what your chosen subject. Learning at Oxford was in a sense a somewhat voluntary matter: an immense amount of the finest imaginable education was available, on tap, and it was up to each student to avail himself of it, or not. One of a tutor's tasks was to suggest how best to do that.

An English don, for example, might well riffle through his own students' lecture list, suggesting which performances might be attended, which could or should be avoided. He might begin by deploring the Tuesdays when 'Porritt spoke on the Elizabethans', urge that no notice be made at all of 'Swithington's barbaric views on Walter Scott', and might recommend attending 'Lord David Cecil's lectures on Lamb and Hardy', though 'certainly not' his talks 'on Walter Pater or Jane Austen'.

Geology was much the same. 'It is all very much up to you,' said Harold. 'Come along only if you wish, and if you do wish then I urge you to hear Lawrence Wager on the Greenland basalts, Malcolm Brown on layered igneous intrusions more generally, and McKerrow on terebratulids, in which he's *thoroughly first class*.

But the thing about Oxford is, and it is true for all departments—classics or modern languages or philosophy or medicine or here at geology—you learn at your own pace, and if you don't learn you'll just not pass your examinations, and the whole exercise will have been a waste of time. Which would be a frightful shame, wouldn't you think?'

'But,' he added sternly, a darker tone to his voice—'you do *have* to come to tutorials. That is a solemn obligation. Every Monday, 10 o'clock. And then we'll see what you know, and what you have learned.'

The arrangement he outlined was most simple. At the end of each meeting one's tutor—and here I shall stick to Harold Reading, but it is much the same in whichever is the chosen discipline—sets the topic for an essay. In my case, at the end of that first encounter on my first Monday of Michaelmas Term, he set me my initial foray: 'The Silurian, three thousand words. *The Importance of the Silurian in History*. Bring it along next Monday,' he said. 'Ten o'clock.'

As I left he gave me one further piece of advice. 'Buy a bike,' he said. 'Impossible without one. Especially if you want to have fun here. And get here on time.'

And this I duly did. Four pounds got me a second-hand boneshaker: three Sturmey-Archer hub gears, a bell, two lights (for the Oxford constabulary was *very strict*, said the shopkeeper), upright handlebars, and a wicker basket between them. I was now able to wobble, then to speed, from place to place—for Oxford is much spread out, and to travel from lecture to library to college to laboratory took time and shoe-leather. Most of us had bicycles: some very few had scooters and a vanishingly tiny number—me one of them, as I shall recall—owned motor cars.

I had six days, and an essay to write. The internal details of what I would eventually write about this 25 million-year-long period of ancient geologic time are scarcely relevant here. But the mechanics of how such a chore is accomplished are unvarying: they require, very basically, the reading of books. And books in Oxford, which exist in immeasurable abundance in hundreds of libraries, are to be found in the greatest quantity and variety in two principal places: Blackwell's and the Bodleian.

* * *

Blackwell's was at the time perhaps the greatest bookshop in the land—only Foyles in London was said to be larger, while Heffers in Cambridge offered a watered-down version, as quite befitted *the other place*.

It was a large shop, built on many levels and in many locations on and around and near Broad Street. Each floor, each outbuilding presented a veritable treasure-house of books, all most alluringly displayed for the taking—back in the 1960s it didn't really seem like a shop at all, more a storehouse or a lending library, which is apparently how some of the more enthusiastic students regarded it. Hence the small and carefully letter-pressed notices on the stores' walls, each framed in gold and headed with the words *Verb. Sap.*—which even philistine non-classicists recognized as a Latin abbreviation for 'A Word to the Wise'—and which warned of the moral impoverishment of shoplifting. Temptation was on all sides. Every imaginable new book was to be found in Blackwell's—certainly, for my purposes, as much material on the Silurian as the cleverest specialist could require. But more importantly, it was clear that they wanted my business, as a paying customer with a good three years of potential purchasing ahead.

Like so many of the shops in Oxford at the time, credit was extended in importunate fashion, quickly and perhaps rashly, for it was possible to build up big bills very quickly. So far as Blackwell's was concerned I merely had to announce my college and my year of matriculation—the date when I formally became a member of the university—and, voila!, I had a credit account, could take away as many books as I could carry, and would receive an invoice *in due course*.

Permission to use the Bodleian, on the other hand, required a more formal process, as befits the most glittering—architecturally, spiritually, intellectually—of all the institutions that make up this university.

The central buildings of 'the Bod' and its neighbours form the physical heart of Oxford; its precincts, all erected in an impenitent frenzy of construction in the late fifteenth and early seventeenth centuries, are what the visitors come to see. The results of the labours are the iconic buildings of the university—the Radcliffe Camera and the Clarendon Building, the Sheldonian Theatre and the Old Ashmolean (which is now the Museum of the History of Science, with the world's finest collection of astrolabes). Together with the ancient colleges of All Souls, Balliol, Brasenose, Lincoln, and Exeter grouped respectfully around them, they represent the central majesty of the place, and are made all the more properly majestic by being devoted, near-entirely, as a central gathering-place for enormous collections of books.

The collections which amassed around the volumes gifted by a sixteenth-century benefactor, Sir Thomas Bodley, now make up one of the greatest libraries in the world—a legal deposit library, which means that all books published in Britain may be sent there (as well as to the British Library, the National Libraries of Scotland and Wales, that at Trinity College in Dublin, and, not surprisingly, the University Library in Cambridge).

Sir Thomas was generosity personified. 'I will take the charge and cost upon me,' he wrote in a letter to the vice-chancellor in the late sixteenth century, 'to make [the library] fit and handsome with seates and shelves and deskes and all that may be needful, to stirre up others mens benevolence to help to furnish it with bookes.' The centrepiece of the Bodleian today—'fit and handsome' indeed—is the dark wood panelled oblong chamber of Duke Humfrey's Library, where some of the original shelving is still in place, the books placed (primarily for the benefit of tourists) upon them backward, their spines to the wall so that the chains that bound them securely could fold up behind, unseen.

Duke Humfrey has the aspect of serene privacy (and an immediately recognizable smell which some commercially minded member of staff has bottled and tinctured and now sells in candle-form in the gift shop, for those who want to reminisce) that suggests that only scholars on the noblest of literary missions are allowed entry. In fact anyone registered as a Bodleian reader may read there, and youngsters in jeans and tee-shirts may be found among the carrels poring over ancient volumes, where once men in ruffs and leggings read five centuries before, when the books were new.

My own favourite spot to use the Bodleian is up in the balconies at the Selden End, where at each corner there is a tiny nook, with a small desk, a bow-back chair, and one low-wattage lamp. To be able to work there, well hidden away, surrounded by volumes of marvellous antiquity, bathed in the aroma of elderly literature, with other bookish people gliding silently below on their various missions, and then with the daylight waning and church bells outside chiming the hours in friendly disagreement, until finally at seven you are asked to vacate until the next day—why, there could surely be no imaginably pleasanter way to learn, to read, to improve the mind and spirit, anywhere, ever.

To win this privilege of entry you had to swear an oath, out loud, to an officer of the library. I did so in that bewilderingly busy First Week of Michaelmas Term, in 1963; but to

my regret, because it seemed so charmingly antiquated a custom (like so many hereabouts) never had to do it again, even after many years. For when I arrived at the admissions desk in 2016 the young lady looked up my name in a moth-eaten ledger, found the handwritten notation from fifty years before asserting that I had indeed recited and sworn the sacred oath, and waived the requirement. Moreover, since I was also the holder of an MA degree from the same institution—'from us', she said sweetly—all fees were cancelled as well and I was to be permitted to use all of the various libraries in perpetuity, or until the end of my life, whichever came first. (The Bodleian's admissions officer at the time, and to whom I offer my gratitude, is also holder of an irredeemably splendid and classically British name, perfect for a great Oxford library: she is Helen Wilton-Godberfforde.)

And all of this—the right to examine and read the pair of First Folios held there, to consult Italian railway timetables or wooden printing blocks of Buddhist teachings, to browse the Oppenheimer Collection of Hebrew Manuscripts or Richard Gough's great eighteenth-century topographical collection, as well as any of the millions upon millions of lesser works—was to be gifted to me back in 1963 upon my recital of sixty-one words, which I was to read out loud from a laminated sheet, or from a chapbook which has their exact equivalent in more than 140 languages, including Finnish and Faeroese, Basque and Burmese, Swahili, Maori, Tifinagh, Amharic, and Tamil. And Latin, naturally.

The translation of the original Latin statute, which dates from Thomas Bodley's seventeenth-century founding, is entertainingly severe. Before entering the sacred purlieus of the library, with your mind properly framed 'in modesty and silence', you are enjoined to 'neither in your own person steal, change, make erasures, deform, tear, cut, write notes in, interline, wilfully spoil, obliterate, defile or in any other way retrench, ill-use, wear away or deteriorate any book or books, nor authorise any other person to commit the like; but, so far as in you lies, will stop any other delinquent or delinquents, and will make known their ill-conduct to the vice-chancellor or his deputy within three days after you are made aware of it yourself; so help you God, as you touch the Holy Gospels of Christ'.

Today's version is no longer recited out loud except by external readers and it is less windy and more mild, but memorable nonetheless:

I hereby undertake not to remove from the Library, or to mark, deface or injure in any way, any volume, document or other object belonging to it or in its custody; not to bring into the Library or kindle therein any fire or flame, and not to smoke in the Library, and I promise to obey all rules of the Library.

It is the 'fire and flame' that unsurprisingly lingers longest in the mind—years later library users remember the moment, and the barely suppressed giggle from some, perhaps, during the recitative—but it is the total ban on ever removing books that has caused the most rancour over the years. For the Bodleian never lends its books: the first of many refusals was to no less than King Charles I, who forty years after the library opened sent an equerry

and commanded the Librarian to 'Deliver Unto the Bearer hereof for the present use of His Majesty, a Book Intituled *Histoire Universelle du Sieur d'Aubigné*: and this shall be your warrant.' The functionary offered a courteous but emphatic refusal, quoting the statutes, and a chastened King Charles, bowing before an authority clearly greater than his own, sullenly withdrew his application.

Branches of the Bodleian are liberally sprinkled all around the city, like fairy dust. Since I was a geologist my closest repository was to be the architecturally rather uninspiring Radcliffe Science Library, just a few yards from the department's front door. More exotic collections are spread more distantly: the Chinese Library is on Canterbury Road, the Japanese on Winchester Road, the Slavonic and Modern Greek on St Giles, the Oriental Institute on Pusey Lane, those separately devoted to Plant Taxonomy and Ornithology on South Parks Road, and on and on.

I have a particular affection for the immense modern structure of the St Cross Building at the corner of St Cross and Manor Road, which was built in the mid-1960s—and in small part, by me. There is a section of brickwork on the building's southern edge which I can say with some pride, I laid. It was a vacation job, in 1965; two pounds a week, if I recall.

<p style="text-align:center">*　*　*</p>

Thus prepared for my coming tutorial—oath duly sworn, library card duly handed over—it just remained for me, during those first heady days of First Week, to buy my uniform, the clothing I would be obliged to wear at important moments in the university year—tutorial included. The university requires students to dress with total formality for matriculation, graduation, and examinations—for both men and women dark subfusc, as it is known, with black shoes and socks, a white shirt, and in 1963 a white bow tie (subfusc nowadays covers far more options). And also, most crucially, a cap and gown.

The gown was to be worn in hall for dinner, and on any appointment with a senior member of the university. There were two types of gown, the wearing of which, the *entitlement* to which, imposed on its wearers, and in a typically British way, a vague but visible class distinction: most of us wore the short bum-freezer of a black commoner's gown with its two flowing tabs that a creditor might in theory grab to halt your progress should you wish to scarper, not paying a bill. But a few of the cleverer undergraduates, who had been awarded scholarships of one kind or another, would sport the longer all-enveloping scholar's gown, not unlike those worn by dons and senior members. Whichever, though—a gown had in my day to be worn for a tutorial, and for dinner in hall, though there is some relaxation of the rules today.

No slipping of standards at examination time, however. The full monty, the total uniform, mortar-board to well-shined shoes, white bow down to neat black skirt or trousers, and the aforesaid gown, had to be worn throughout.

There are stories of those who occasionally try to poke fun at the system. Most famously we learned of one undergraduate, a swell from so grand a titled family that he was permitted

to wear a tuft, a gold tassel, on his cap, who looked into seventeenth-century rules that, he claimed, permitted him to order food during the examination itself. An hour into writing his paper he announced that he was feeling peckish, summoned an invigilator, and demanded— sotto voce so as not to disturb his neighbour candidates—that he be brought a steak and a glass of claret.

The invigilator took it all in his stride. The food was duly brought; but with it came a formal note, quoting the very same seventeenth-century rules, fining the undergraduate a guinea for not wearing, as the rules required, his sword.

* * *

As I slaved away on my first essay there was one final rite of passage, a tradition familiar to newly arrived undergraduates in colleges around the world—but which in Oxford (and in all probability across in Cambridge too) offers an indication of the near-limitless range of delights available during the three precious years to be spent in Keats's 'finest city'. The Freshers' Fair puts on display what pleasures are to be had here, when all the scholarly work is done.

The fair is sensibly held at the start of term, and is these days much larger and more organized than during my years. Nowadays it is held in the Examination Schools, a formidable and heavy Victorian building close to the corner of the High and Merton Street, copied from a vast Northamptonshire mansion. Usually this is a forbidding place, since it is where you take your final exams and have your fate decided; but for three days each autumn it is much more fun, set out like a marketplace, with stalls and carnival barkers, and where all the scores of societies and clubs and associations which a student might wish to join, or avocations which he might wish to pursue, are on show.

I lingered long there back in 1963, pausing at various brightly decorated stalls where eager students showed off their wares, importuning me to join. I examined the cavalcade of joys on offer, and ended up with a cluster quite as varied as I imagined. I joined the Exploration Club, which promised rigorous adventures far away. I decided to take up rowing, and applied to train with my college boat. I liked the sound of the Gilbert & Sullivan Society. I thought I might take up chess, and learn something about wine—Oxford being abundantly supplied with amply stocked cellars. And so when I stepped back out into the rain that afternoon I had a clutch of cards and calendars and almanacs, and a heady programme before me of sherry parties—the social device of the times being medium-dry sherry and leathery cheeses—by which each of the various groups invariably introduced new members to one another.

* * *

I had to put all these delights on hold, however, in order to prepare my first 3,000 words for Harold Reading. I needed to impress him on my first encounter, I thought, I needed to display to him that I could indeed write and offer up a case and argue coherently and with

economy. 'The Importance of the Silurian in History'—but the more I thought about it: in what history? Of Geology? Of Britain? Of Science? The question was deceptively simple, and it required thought rather than rote. The kind of question, in other words, that made Oxford so special a place to learn.

And in consequence of that realization, so many hours were spent in the Radcliffe Science Library—my new Bodleian card allowing me immediate access of course—and many pounds were spent at Blackwell's, and many evenings were spent composing and writing and rewriting at my desk before the window and its tempting view of the newly planted college gardens. Finally, at about two on Monday morning, it was done: ten pages of handwritten logic and disquisition, or so I hoped, ready for my first tutorial. I put on my gown after breakfast and cycled up to the department, in a slight drizzle. I knocked on Harold Reading's door at ten exactly. He was sitting in a low leather chair, examining a small grey slab of rock, which he tossed to me.

'Know what that is?' he asked. There was a fossil embedded in one side.

'A trilobite,' I replied.

'Yes, yes,' he said with slight exasperation. 'But what, exactly?'

I didn't know.

'No matter,' he said. '*Dalmanites*. A classic Silurian trilobite. Know it from its pear-shaped *glabella*. Important for you to know it. Especially since you're about to tell me why the Silurian is important.'

And thus, set immediately on the back foot, I read my Silurian essay. It took me half an hour, and Harold sat back in his chair, hands arranged as if at a *prie-dieu*, listening intently but never once interjecting. I finished and sat back, and waited.

He had listened, it turned out, with rigorous intensity, for he picked up on phrasings and word-choices and repeated them back to me with total accuracy, asking why I had said this in that sentence and why the tone in that paragraph was so different from its predecessor . . .

But in the end, his verdict: 'not half bad for a first attempt.' And before I could sigh with very evident relief he started to tell me about a recent expedition to Finnmark, and his discovery of some interesting unconformities there—'just like those you'll see on our field trips'. Because we were going to many places together in the coming years, he promised. Derbyshire. Arran. The Isle of Mull. Ardnamurchan. Skye. 'You're going to see a lot of the world during your years here,' he said. 'Much fun awaits. Now—3,000 words on, let me see—"Why Have a Love Affair with a Trilobite?" How does that suit? Next Monday. Ten o'clock. Have fun.'

* * *

You may remember Waring, my companion back when we took our examinations at Pembroke. His anxiety and pessimism were misplaced, for he had also won a place at St Catherine's, and he announced early on that he was keen to row. So after we met each other at the Freshers' Fair we commenced a friendship that lasted for at least the first two years of

our time at Oxford—a friendship that was bound by the myriad delights of spending time on the river.

And by 'the river' one generally means the Isis. Oxford is sited where this main stream is joined by a tributary, the Cherwell. And though the Cherwell is central to the more languid idylls of an Oxford education, it is the Isis where the rowing is done. It may be thought of as the workplace, while the Cherwell is a river designed near-entirely for having fun. Let us consider the workplace stream first.

It is a sturdily flowing river, deep and muscular and populated all year round by myriad watercraft (and waterfowl: serene-gliding swans especially, and mallards and ducks and yellow-feathered ducklings of charming assortment). In the high summer when the students are away, hired pleasure boats chuckle along the stream, their speeds strictly limited by the River Authority so as to afford protection for the banks, with their voles and other creatures that shelter within. Once in a while these boats will tie up to conveniently placed stakes so that their occupants, who are usually wafting from Reading to the upper navigable reaches of the river in the Cotswolds, may disembark and gaze in wonder at the Oxford spires and towers across the meadows. Mostly though they drift along, music mingling with the engine-sounds, with the fellow at the wheel, usually a Londoner with little experience of boats, looking nervous and white-knuckled as he leads around the bends. There is one nastily narrowing turn known as The Gut where pleasure sometimes turns to grief, and where not a few craft thud into the side, to embarrassment all round.

During the rest of the year, though, the university takes back its near-monopoly on the Isis. Most of the craft afloat then were those belonging to the college boat clubs, and these were craft propelled not by engines, but by fit-looking young men and women, among whose number Waring and I counted ourselves during our first two undergraduate years.

We were welcomed enthusiastically into the company, and asked which kind of boat we favoured:—a scull, perhaps, in which you row with two oars, and alone; or a double-scull, where two of you do the same thing; a coxed-pair, in which a small person sits facing you and steers for the two of you, each now rowing with a single oar; a coxed-four, in which four of you also row with only one oar, and have a coxswain to do the steering; or, most probably, an eight—the boat for which most boat clubs are known, and which all who indulge in the sport know is an essential for the encouragement of *teamwork*.

The club captain was vehement in repeating this to the pair of us as we filled in our forms and paid our dues. You can idle at the back of the field during a game of rugby, he said, and, for a while at least, get away with it; but idle in a boat while your seven colleagues are working hard to keep up speed on the river is immediately noticeable, and *unforgivable*.

Sir John Bell, the university's current Regius professor of medicine, is a keen believer in the importance of the sport of rowing, and of how it meshes neatly with the demands of academe. Persistence, hard work, and teamwork, all *sine qua nons* of rowing, are equally applicable to an Oxford education—for what might appear to be the solitary demands of

study are matched by the pride you take in helping your college to do well in the various league tables that mark one college as academically superior to another: you perform as well as you can on the river and in the library: your club and your college benefit every bit as much as you do, if you win your races and achieve a fine degree.

Sir John's advice was not available back in 1963: but the captain's exhortations were, and so we cycled down to the river, and the boathouse with a sense of determination and purpose that, I suggest, remained with us for the rest of our lives. These days St Catherine's keeps its craft on racks in a handsome cement structure with sliding doors that enable a crew to hoist a boat directly from rack to stream; back in the 1960s we, like many other colleges with limited funds, had an enormous and ornately fretworked Edwardian floating houseboat, painted in the college colours, tied up to the side. In this monstrous craft, looking somewhat like the boats on Dal Lake in Kashmir, we stored our boats and our oars, and in the summer season we would hold parties on the roof, from which revellers would dive into the river, with swift and sobering results.

Heavy, clinker-built boats are used in the winter months, lighter and more graceful carvel-built craft, their wooden struts lapped edge to edge rather than overlapping in the heavy boats, were employed in the summer of my times (Kevlar, fibreglass, and carbon fibre seem these days to have erased the distinction). The craft are assigned to the classic Oxford races which take place in February and again in May—the former known as Torpids, the latter, held in the Fifth Week of Trinity Term, known simply as the Summer Eights.

In both events the methodology of the four days of what is known as 'bump racing' is brutally simple—quite literally brutally so, if somewhat bizarre. The boats from the forty-odd colleges are first arranged in leagues or divisions, all sorted in the order in which they finished in the races held the year before. What happens then is this:

Each race is started on the sound of a cannon-shot. All eight of you, the cox anxiously gripping the rudder-strings, come forward, knees bent, oars perfectly aligned back as far as they will go. There is a countdown—'the tensest moment you will ever know in your life', a coach once said to me, and I believe it to this day, since all in your boat and your college now depend on you—and then the cannon fires and as one you and your crewmates pull back on the blades, and the boat shoots forward into the maelstrom of foam and spume and wild water and a roar of blurred cheering, cheering, cheering.

Your goal is that simple brutality: on the first day you try to go so fast that you bump the stern of the boat ahead of you with the bow of yours—in which case both boats (though in summer only) stop rowing. If you do manage to hit him, then you exchange places for the next day's race, the bumped boat being demoted, the bumper being promoted. If you are good, and fast, and skilfully steered by your coxswain, you can possibly climb four places in four days (more if you race past the boat in front of you and bump the boat in front of him—a summertime-only occurrence called an overbump)—and if you are very, very good, then you will get to the head of your division and if your division is at the top of the league,

become Head of the River . . . at which point in the explanation eyes glaze over, people turn away, and who can blame them?

Oxford rowing, in Oxford itself, is nothing so clean and tidy as the Oxford against Cambridge Boat race, which is held on the Thames in London and just puts the two so-called Blue Boats (dark blue for Oxford, pale for Cambridge) side by side, to see who can win a race over eighteen minutes of riverine fury. That may be how they do it down in London; up in Oxford it is all about bumping, is almost on the verge of amiable violence, and it encourages a passion and a loyalty to college and crew that, as Sir John Bell might say, proves a spur to achievement and success in worlds far beyond the placid stream at the lower end of Christ Church Meadow.

* * *

Waring and I would cycle down to practice day after day, week after week, and we would become determined and impassioned by our involvement. I remember most vividly that grey and bitter Friday, 22 November 1963. We had been on the river all afternoon (there were seldom classes on Oxford afternoons, the better to allow for diversions such as this) and had come back to college to warm up by the fire in the Junior Common Room, and have tea and crumpets bought from the buttery. But when we arrived everyone was gathered around the television, their faces grim. The American president, John Kennedy, had been shot and wounded in Dallas.

Waring and I had tickets for the cinema that night, and as money was tight we decided to go, no matter what. It must have been 9 p.m. when we left the cinema—3 p.m. in Texas. The city was hushed. No one was about. It was raining. We knew just why.

And the film we had seen? It was the Italian documentary *Mondo Cane*, which had advertised itself as 'displaying mankind at its most depraved and perverse, displaying bizarre rites, cruel behaviour and bestial violence'.

* * *

I don't think we did very well in Torpids that first year; but in May, following a week of hard before-term training at the downstream market town of Wallingford (in the shadow of Agatha Christie's house) and with the sun blazing and much prettiness and bliss all around us we did well enough. I will always remember with pride the sound and feel of our bow lurching left and hitting home against the hull of our rivals ahead. We went up two or three places that year. Not enough for a bump supper—which the college gives for a triumphant crew (a crew making Head of the River is generally permitted to burn their winning boat in the college quadrangle, to scenes of joyous bacchanal). No, we won neither supper nor bacchanal, but our performance was good enough, and it was repeated the following year, setting St Catherine's, then something of a stripling rowing college, well on its way to becoming one of the better and more successful on the river today.

There is one other magical pursuit that takes place on the river, and which first makes its presence known each May, at dawn on the month's first day. Punting. The word is from the Latin—think *pontoon*—and it is a skill or a pastime, which when done properly or a little less so, can be as idyllic a means of wasting time as can be divined.

Although the time when most first-year students get their initial glimpse of punts in action is rather more chaotic than idyllic. Perhaps, indeed, it is the most chaotic moment in the Oxford year, since it revolves around the ceremony known as May Morning. This, staged always at 6 a.m. on the first day of the month of May, rain or shine, marks the official beginning of spring. The season is formally welcomed by the singing at dawn of the ancient *Hymnus Eucharisticus*—both words and melody composed by a seventeenth-century Oxford don—from the top of the great tower of Magdalen College.

Great crowds gather below to support the ceremonial—and since beside Magdalen Tower there is Magdalen Bridge, and since a dozen feet below the bridge are the limpidly tempting waters of the river Cherwell, and since much of the merriment involves drink and since the weather is most often just becoming amenable for swimming and boating and diving—so students in their scores have been given to leaping manically from the bridge into the river, or to simply being on the river in boats—many of them punts, hence the familiarity that the ceremony occasions for newcomers—all night, with amusing and occasionally dangerous consequences.

My first May Morning I did spend the entire night on the river, not in a punt but in a skiff of some kind, in the company of a group of friends whose antics and varying weights caused us, eventually, inexorably, and inevitably, to capsize. To turn turtle, in fact, and to do so in a deep and slow gurgling reach of a deep dark river in the depths of a deep dark night. None was drowned, and in due course we righted ourselves—no easy task when tipsy—and as dawn rose we gingerly approached the scrum of all the other flotillas beneath the bridge, well aware that we were damp and miserable. We saw nothing worth seeing that May dawning, but a few far-too-distant glimpses of young men leaping from the parapets, to be followed by splashes, triumphant cries, and waves of drunken girlish giggles. It was by no means a satisfactory encounter.

For the remaining years I was more prudent, more mature. I rose from my college bed—Eric the scout on hand with a cup of tea, even though it was four in the morning, and the sky was only vaguely limned with the first blue and gold dusting of dawn. He placed a scarf around my neck as I left the room: 'Most gentlemen in my experience come home very cold,' he said.

I walked the half-mile to the bridge, the crowds of the similarly sleep-deprived thickening as I got ever closer. By the time I reached the dawn-yellowed limestone tower—building had been commenced in 1492, it remains today the tallest building in the city, and is home to a great array of metal bells that peal out joyfully on ceremonial occasions—it was all-but-impossible to move. People jostled happily together, a solid mass of young humanity dressed in a wild variety of costume. There were young men in dinner-jackets, bleary from far too

much port. There were young ladies in extravagant ball gowns, shivering in the morning cool and persuading their companions to loan them jackets for their bare shoulders. There were morris dancers in strange white costumes with rushes and bells tied to their wrists and ankles, handkerchiefs in hand, arranged in circles dancing gamely to tuneless dirges from a penny-whistle. And there were visitors, puzzled and bemused and enraptured by it all, and not a policeman in sight nor any bad behaviour at all, just gaiety and laughter and the good tidings of the coming season.

A peal of bells announced the sixth hour of the day, and everyone tried for a moment of silence, so that we might hear the choristers above sing their madrigal and their welcoming hymn. When I was a student it was well-nigh impossible to hear, and after a minute or two of straining to hear the faintest sibilance from the skies we would all give up and the ground-level quiet would give way to raucous partying once more.

Vera Brittain, the Great War poet who studied at Somerville College, was intrigued by what she thought was a peculiarly Oxford segue—no more than an hour would pass between solemn hymn-singing and orgy (generally respectable) of wild exuberance—and she caught the mood of the morning's early moments, quite perfectly:

> The rising sun shone warmly on the tower,
> Into the clear pure Heaven the hymn aspired
> Piercingly sweet. This was the morning hour
> When life awoke with Spring's creative power,
> And the old City's grey to gold was fired.
>
> Silently reverent stood the noisy throng;
> Under the bridge the boats in long array
> Lay motionless. The choristers' far song
> Faded upon the breeze in echoes long.
> Swiftly I left the bridge and rode away.

The 'choristers' far song' was so very difficult to hear, back then. But these days Magdalen College—one of the richest and proudest in the university, with a great park lively with deer (once said to have been sugar-lump-drugged and kidnapped by Lawrence of Arabia, and led along the High to All Souls where their new keepers insisted they had been there for centuries)—has paid for an elaborate sound system, and so the hymns can all be heard, as if in an open-air concert hall. The crowds below now do succumb to the serene beauty of the moment and remain on good behaviour for at least ten minutes while the official welcomes are performed.

But then the singing stops, the crowds are unleashed, and such as care little for breakfast and are dry enough and sober enough to imagine they can steer may then venture down to the riverside to find, if possible, an available punt to employ on a cool morning's riverborne saunter through into the countryside that girdles the waking city.

It is an experience to be savoured for ever: I would suggest that anyone who has ever punted in Oxford (and to be fair, I daresay much the same is true for Cambridge) always remembers the sheer joy of the experience.

Particularly, that is, if you learn how best to do it.

A punt is flat-bottomed and long and lumbering and is propelled by the use of an almost as long and metal-tipped wooden pole—properly but seldom called a quant. Oxford punters stand by Victorian tradition at the open end of the craft; Cambridge stand on the till, a flat and yard-long deck which, it was said, allowed women punters in Edwardian time to expose their ankles to men on the river banks. Oxford women, perhaps not needing such advertisement, sought only to be competent at the sport, in which both sexes could display considerable elegance, if their technique was good.

In summary: once the punt has been pushed away from the bank, the punter standing, hoists his pole and tosses it high above him, until the metal shoe is exposed, free of the water. He then drops it back into the river, at a point about one-third of the way along the side—usually the right hand side—of the punt and, carefully ensuring that its top is sloping towards the bow of the punt and the shoe is safely dug into the riverbed, he pushes down steadily on the pole—thus moving the craft forward. As he lets the pole out, hand over hand until he reaches its top, he will be stooped low to ensure that as much of the pole as possible is submerged and that the boat is thus moving swiftly in the right direction—a direction also dictated by the direction of the pole. The punter then pulls the pole back up out of the water and, with a subtle flick of the wrist that ensures no water dampens his sleeve, he hoists it back up again, frees the shoe from the water, and prepares to plunge the pole back down into the river once more.

A steady rhythm—one up-and-down pole cycle every ten seconds or so—and the punt can go at quite a lick, smoothly and without so much as a jerk to disturb the tranquillity of passengers. They will only notice if you get matters wrong. Most will be dangling wine bottles into the stream to keep them cool, or will just be lying prone and watching the sky and the passing willows overhead, or the cattle or horses in the meadows drifting alongside.

There are perils aplenty for the fellow doing the work. He must take much care for the twists and turns of the stream, and even more care for an unexpected deep (where you might lose the pole, or your balance) or an unanticipatedly muddy river bottom (which can snag the pole's shoe and entrap it and leave the punter to decide whether or not to hang onto it and lose the fast-moving boat and maybe plunge into the fast-opening gap of water between).

Many are the accidents—most of them trivial, involving generally little more than a loss of dignity and dryness. But an afternoon of punting perfection—with everyone aboard marvelling at your skill, your speed, and the way in which water from the pole manages to spin off into the breeze never once dampening your white linen slacks and your smart cotton blazer—offers a thoroughly pleasing moment of glory. It also offers an assurance (and here I write this in the persona of the young buck I thought I was, back in 1963) that should you

ask the most agreeable of potential companions if smoked salmon and Sancerre at some isolated bankside in the sunshine would be acceptable, your invitation, since you are known to be a capital punt-master, is assented to. Your companion will be settled on the cushions with which the better college punts are supplied, will gaze dreamily about, will listen to the ripples beneath the bow, the breeze in the trees, the birdsong, the distant sound of chiming bells, the cries from young bloods playing cricket in fields beside the river.

In my day there will have been the occasional interruption: if your companion was a lady she would be obliged en route to disembark as the boat swept by Parson's Pleasure, a small cul-de-sac in the Cherwell where men were allowed to bathe naked; and if a man he—and you as driver—would have been urged to do the same at Dames' Delight, where ladies used to bathe in full undress—a female guest may well have had to take over the pole herself for the few hundred feet of forbidden passage. (In truth I don't exactly recall how two men could possibly have manoeuvred their boat around the hazard: but in any case the enthusiasm for riverine gymnosophy dimmed soon after I went down; Dames' Delight closed in 1970, and the practice ceased altogether in 1992.) Depending on how far upriver a couple venture, the lady of a pair may still today be expected to help push the boat over the iron rollers that allow for the passage around the weirs that divide the stream's levels, and which keep its flow more serene and rapid-free. A summertime punt expedition is an occasion that requires work from all, and the rollers can be hard work indeed.

All the more understandable, then, that when the perfect halting-spot is found, and the salmon and the river-cooled wine are done with, and your companion has wearied of the sketchpad, both of you will doze in the leaf-speckled sunshine. And then it will be evening, and both will wake to a faint chill in the air, energizing your punt home through the twilight, and your walk from the punt station back to college, at the end of a long and perfect Oxford day.

Those were the days, those the dreams. And though there is much more to Oxford than sybaritism and languor—there is hard academic work aplenty, and brutal competition—it is the moments of pleasure that most seem to take away with them, and which will mark their Oxford years as among the happiest of their lives.

* * *

And there is also, before we leave the topic of the delights of Oxford, the matter of balls and feasts.

Oxford provides the perfect backdrop for grand events. Not state-visit kinds of events, with marching and massed bands and windy speeches delivered before thousands; but grandly stylish events, intimately played out in ancient dining halls, perfectly finished quadrangles, and in marquees tricked out with more decoration than one might ever conceive.

College feasts—the invitations rarely offered but swiftly accepted—are truly Lucullan affairs, black tie and miniatures, extravagant cocktail wear, battalions of candles, good silver and crystal, numberless courses, and with the most distinguished clarets and burgundies

hoisted up from the coolest recesses of the cellars. Invariably the dinner is divided into two. There will be the bacchanal of the first courses, then an interlude, followed by a clever re-*placement* of the guests for desserts, such that one sipped Sauternes and venerable ports—passed always to the left, as ritual demands—and consumed crystallized ginger and figs and brandied peaches with an entirely unfamiliar neighbourhood of guests.

At my most recent feast—for St Catherine's kindly asks me every few years, having elected me to an honorary fellowship—I found myself pinioned between an American ambassador to Croatia, a formidably clever leader-writer for *The Times*, and with a titled Dame across from me, a lady said to be the cleverest in the realm and one who had written the definitive study of those people whose lives are devoted to the veneration of the Virgin Mary. Next, when it was time to take the Chateau d'Yquem and the Stilton, I had a Parsee financier to my left, a distinguished quantum physicist to my right, and opposite, a professor of geography who had a special interest in the immense Utah landholdings of the Church of the Latter Day Saints. At a feast you eat nobly, you drink superbly—and you learn much.

Less so perhaps at your college gaudy, which (though the word derives from the Latin for merrymaking, and to serve as a reminder of the brevity of life) is a little more threadbare version of a feast, with old members from a certain year or years gathered together as at an American high school reunion. These are livelier affairs—near murderously so, to fans of Dorothy L. Sayers—but are designed with catch-up camaraderie in mind, rather more than a superabundance of Epicurean and intellectual treats. A gaudy is fun; a feast can be daunting.

And a college ball—most especially a Commemoration Ball, held every three years or so, and staged at the very end of Trinity Term—can be both daunting and fun. And very costly: even in my day the much sought-after tickets, which were lavishly printed to hint at the level of sophistication to come, went for a sum in guineas that often required a loan from one's parents.

But the evening, especially in the older colleges, can be exquisite. The quads are all lit, spectacularly and prettily. Everyone is in the most formal wear possible—the men in white tie and tails, the young women in lavish and multicoloured gowns of silk and linen and organdie. There is a map to indicate where the various events are to be held—there will be a main dinner in this hall, a rock band in this quad, cool jazz in that, a string quartet playing in a marquee by the river, barges with choirboy madrigals departing upstream at midnight, there will be fairground swings and roundabouts and dodgem cars on the south lawn, the Massed Bands of the Grenadier Guards will perform on the north lawn at 2 a.m., fireworks are at eleven and three, and there are ice-bucket dispensaries with endless wells of fine champagne, and there will be a seamstress, always a seamstress, a capable and comfortable seamstress, who is stationed on one particular staircase throughout the night for any lady who dances too enthusiastically and does supposedly irreparable damage to her gown.

No eventuality goes unanticipated—and legions of security men are deployed beneath the walls to ward off any gate-crashers, who often try to see whichever famous band is invited to play. The Rolling Stones were at the Magdalen Ball to which I took my then girlfriend in

1964; I heard that The Beatles and The Who were to be found at a neighbour college, though at the time we thought we had the better of the deal. Some gate-crashers got through: climbing over the walls of an Oxford college—which in those days shut and locked their students in each midnight, like the monastic institutions they once were—was a popular sport, and serial climbers well knew the best lamp-post to shin up and where conspiratorial ladders might be placed inside, and so we would welcome those who made it, feeling that they had earned their fun. (One undergraduate, famously but perhaps apocryphally, demanded of an elderly passer-by that he give him a leg up, and slipped him five pounds for doing so. 'What's your name,' cried the senior figure as the youngster breasted the top of the wall. The next day the student received an envelope: inside was the five pounds returned, and a note from the university vice-chancellor, no less, regretting that he was unable to accept payment from a junior member of the university. It had been very pleasant meeting him, however.)

* * *

And yet beneath and beyond all these trappings of Oxford extravagance, there was, always, the Work. The gaiety—and yes, there was plenty of it—was for letting off steam, a fair head of which developed as the weeks went by, as the lectures became more opaque, the tenor of the tutorials more combative and challenging.

Yet there were diversions, too—aspects of the Oxford life which were most certainly not designed for fun, which were connected in some way or another with work, and intellectual life, though not formally so.

The lively political debates staged with formal ceremonial each week in the Victorian chambers at the Oxford Union provided one such diversion. The left-wing political firebrand Tariq Ali was one of the more celebrated presidents during my time; I recall the year before his presidency when the union brought Malcolm X across from America to speak there. Benazir Bhutto, later to become Pakistan's Prime Minister—and to be assassinated—was at St Catherine's, and a decade after I was there became a leading Oxford Union figure: her skill at arguing her cases in the face of savage opposition there was legendary, said to be always worth watching. There was much to observe and listen to in that building that had hatched the debating careers of so many British politicians over the years.

But I was no politician at Oxford, nor had much interest in the calling, except in terms of the theatre that some politicians provided. As perhaps one might expect of a geologist, the outside world was more my fancy than the cigar-clouded world of the interior. Exploring was more my cup of tea, ever since I had expressed an interest back at the Freshers' Fair—and so expeditions proved for me a much better example of the kind of diversions that were available, on tap.

The Oxford University Exploration Club met weekly in a room on Keble Road and imagined mounting expeditions to the furthest-flung corners of the world. We had perhaps fifty members, and each week we would ruminate on whether to dispatch biology students

to collect blood samples from among the headhunters of Nagaland, to send anthropologists to Lapland, social historians to the ruins of Zimbabwe, or cartographers to the interior of South Georgia. And these were no Walter Mitty-ish fancies: out of the babble of exotic geographic fantasizing there would emerge, each year, half a dozen or so well-thought-out ventures to distant places in the world, each of which would, it was expected, produce tangible results, allow for the publication of an official paper or two, and would strengthen bonds of comradeship and foster curiosity among the students selected to go. To be designated an official Oxford University Expedition was an honour indeed; and I was lucky enough to be one of six youngsters selected to go on the 1965 expedition to East Greenland, the results of which remain of scientific importance today, and the human consequences of which linger still in the memories of all the surviving members.

Our plan was simple. East Greenland, ice-bound, mountainous, largely unexplored, is made up of thick layers of basaltic rock hidden by thousands of feet of glaciers and compacted snow. The basalt is exposed, however, on the mountaintops; and if we could get samples of these exposed rocks and bring them back to Oxford we could provide evidence, or so we imagined, that the much-derided theory of continental drift was in fact a reality, was happening. We put our case for such an expedition to the club; it was accepted; and armed with this imprimatur—and headed writing paper, the expedition titled in embossed dark-blue ink—we began to hunt for money and supplies, and devised a plan for setting out during the long summer vacation of 1965.

It was an extraordinary three months, memorable on many levels. We travelled out on a Danish icebreaker, and took a small Inuit boat across a ten-mile-wide fjord to a landing beneath a never-before-traversed glacier. We trekked up on this ice-pathway for many miles—crampons on our boots to prevent falling—until up on the icecap itself, and from there climbed to the mountains where we would collect our samples. By the time we returned to the landing site the fjord had filled with ice, we had to abandon our gear (but not our rocks) and walk out over the treacherous floes, we ran out of food, had to shoot and eat a polar bear, a goose (shot on the wing), and a musk-ox, just missed our icebreaker back to Denmark and had to cadge a ride to Reykjavik with an Icelandic pilot, and arrived back in Oxford just a day before the start of Michaelmas Term.

Our samples, 200 pounds of dark brown rock drilled with a portable coring machine, turned out to be worth their weight in gold. Microscopic examination in the laboratory proved what we had suspected—that in the thirty million years since the rocks had been laid down, the entire mass of Greenland had *moved*, had shifted westward through some fifteen degrees of longitude. Continental drift was definitely happening, in other words.

Those scores of distinguished scientists and holy men who had declaimed as preposterous the notion that solid continents could actually move were now faced with irrefutable evidence to the contrary—and evidence collected, at some personal risk, by six young Oxford students. Later research by eminent figures confirmed all we had uncovered, and the

foundations for the science of plate tectonics were firmly laid, and announced just a short while later.

Ours was an achievement that, in its minor way, we could rightly say was of some small historical importance—and our decision to go to the High Arctic, and the university's support of our mission, remains still for me an enduring testament to this institution's unique status in the world of learning. The facts were starkly simple. We were students. We went off to Greenland. We made a scientific discovery that would help shake the world. Few other undergraduates at few other universities anywhere in the world would ever have such opportunities. This was Oxford, and at its best.

* * *

It was also the beginning of my final year, and all the expedition work had left me with much academic catching up to do before the dreaded matter of Schools, the final examinations.

By now I was 'living out', as the phrase had it—I was no longer in the motherly embrace of college, with Eric and the Junior Common Room and the college library and the routines of dining in hall or at the buttery. I now had a small flat on Walton Street, above Burbage's, a chemist's shop. The rent was two pounds and change each month, and a strict obligation to hang out of the living-room window each Tuesday morning and wind the large Burbage clock, something of a landmark to passers-by. (There is a chemist's shop still there today, and a clock. But it is electric, and perhaps someone had forgotten to pay the bill, since when I visited it had been stopped for months. As I was an expert, the pharmacist joked, would I mind winding it for him?)

It was in this flat—overlooking a rather seedy cinema that showed dubious films to men who wore long mackintoshes, so there was much temptation for social anthropology—that I studied, religiously and ever more frantically, for Schools.

Walton Street, then as now, was well supplied with inexpensive restaurants. My old rowing partners and I (no longer rowing: we were far too busy in Schools year; and how often did we decline an invitation by announcing that we had *a crisis*, meaning an overdue essay, proving too difficult to finish in too little time) would eat at an Indian restaurant, the Dildunia, which was next door to the chemist's. One of the features of many a pharmacy back then was a weighing machine—put in a penny and it would tell your weight and stamp out a ticket with your fortune—and we had devised a scheme whereby we would all weigh ourselves before dinner, do the same after, and whoever had put on most weight with all those parathas and puris and bowls of rice would pay for dinner for all of us. Or else—I am a little hazy—he had his dinner paid for.

Hilary Term passed, then Trinity, and for all of us it was work, almost non-stop. The delights of former years' Torpids and Summer Eights passed us by; no balls; there was no punting upriver, there were no lazy afternoons at the Perch or on the lawns of The Trout at Godstow. I did have a car—a share in a 1931 Rolls-Royce which had been rather bizarrely

converted into a hearse (and in the back of which one of my chums once placed a spinet, which he would play as we went on outings), and an Austin 8 of similar vintage. Both cars were equipped, as the proctors' rules of the time demanded, with tiny green lanterns on the front bumper which announced that the vehicles belonged to junior members of the university.

I did have one small adventure with the Austin. A vastly distinguished geology professor from Princeton arrived in Oxford early that spring, and agreed to address the Geological Society, a rare honour for us. The students who ran the society—of whom I was one—took the great man out to dinner, as was customary; since I had a vehicle it was agreed we would take him to the Old Swan at Minster Lovell, a much-loved pub ten miles away. He dined heartily and well, and imbibed especially so. On the way back the elderly car, never the most reliable, packed up, doing so on a moonless night, on a road utterly devoid of traffic. No phone boxes were visible—and certainly no cellphones back then. To reach a main road where we might hitch a lift we had to take a short-cut across a ploughed field, with all of us in dinner-jackets and well-shined shoes, our merry-minded professor included.

Two hours late, and mostly covered in mud, we arrived at the geology department to find our audience of more than 200—such was the distinction of our American visitor—still waiting silently and patiently. The lingering effects of good red wine were still apparent, and our man gave a long if slightly incoherent address, and displayed fine good humour about the entire episode. When I met him in Princeton a decade later he regaled his colleagues with highly embellished versions of the saga, which involved a lot of falling over in fields alive with dark images of cattle. His Oxford professorial counterpart at the time took a less sanguine view of the episode, though, and suggested that I take leave from either the society or the temporarily abandoned car, and preferably, as he put it, both.

* * *

And then it was time for Schools. I revised, swotted, prepared, memorized—and in the end decided I knew all I was ever going to know about this particular science, and so on a certain Monday in June dressed myself in tidiest subfusc, placed a white carnation in my lapel (to signify that this was the first day of the week-long ordeal) and strolled with studied nonchalance from Walton Street down along to Beaumont Street and then past the Randolph and the Ashmolean and St John's and Balliol, along the Broad, down the Turl (past Walter's, where when I had hair I had it trimmed, past Duckers, shoemakers *extraordinaires*, past the Mitre Hotel), turned left into the High, crossed it just past Queen's and University College (stepping out into the road just opposite one of the great cultural concatenations of the city—the domed memorial to the drowned poet Percy Bysshe Shelley, which itself stands on the spot where Robert Boyle discovered the compressibility of gases and Robert Hooke discovered the first living cell), and finally presented myself, with minutes to spare, outside the Examination Schools. A great crowd of similarly motivated

young men and women were gathering there too, waiting for the booming announcements from the Tannoys.

'Would all those taking the examination in *Literae Humaniores* proceed to Room 4.' People shifted, and the crowd thinned a little. 'Candidates for the degree in modern languages, Annex Six.' 'Politics, philosophy, economics, Hall One'—much movement here, as so many read PPE. And at last: 'Geography, geology, zoology, botany—Room 9.'

It was a week of agony—handwritten paper after handwritten paper, three hours long, essay after essay after essay on stratigraphy and sedimentology, structural geology and petrology, palaeontology, and mineralogy, the testing of intellect and memory and argument to its very limits. The clocks would tick, the invigilators would command us maintain an absolute silence, and then to 'turn your papers over', just as back in the hall at Pembroke three years before. Much ink was expended, many furrows chiselled into brows, many muttered curses of 'I know that, I surely know that . . .'

After an interminable-seeming week (one's white carnation being replaced for later examinations by pink versions) it was all done—except that as geologists we had one last ritual, which involved the eight of us being taken out in a windowless bus to a quarry in the Cotswolds, there to write a field report and draw a map that would relate which geological horizon we were in, which rock types, what fossil subspecies, what structures—fault, folds, and the like—we could see. A passing farmer would have to rub his eyes on seeing eight youngsters in dark clothes and white ties and mortar-boards (but with boots allowed in place of shiny black shoes) wielding hammers and bottles of acid and compasses and magnifying glasses, divining the secrets of the earth. But then if he was a canny farmer and knew how close the quarry was to Oxford, he would realize what was happening, and keep his own counsel, and let what seemed like an episode of midsummer madness continue, uninterrupted.

And then comes the particular madness that is handmaiden to the end of Schools. Friends who have come know the precise time of the last papers, and by tradition they gather nearby, in their hundreds, and usually with bottles of champagne, waiting for the clock to strike the hour and the doors to be flung open and for the exhausted, inky-fingered, dishevelled, and relieved candidates to pour out, blinking, into the fresh air.

Then the cheering begins, louder and louder as friends meet friends, and then bottles are popped open, and confetti is thrown, and flour and silly string and torn up newspapers and examination papers, and in time a great happy mob, united in having finished it all, having ended study, having done with Oxford, is moving as one great river of relieved exultation down the cobbles of Merton Street under the walls of the Botanical Gardens, there to spend the rest of the day being amiably moved on by proctors and bulldogs and tolerant seen-it-all policemen while passers-by and tourists imagine some fearful riot is under way, when it is in fact no more than unbridled and ecstatic joy.

* * *

'Having done with Oxford', did I say? I misspoke, surely. Those fortunate enough to have studied there can never be properly *done* with the place. Later on you will be invited back to get your degree bestowed—a ceremony conducted in the Sheldonian Theatre in Latin, and with those close to you in attendance as you wear your new long bachelor's gown and watch with pleasure as the vice-chancellor raises his hat to you and salutes your graduation.

I kept my name on my college books for the required twenty-one terms from my matriculation—four years after that first graduation ceremony—and since I hadn't racked up any debts of significance found myself magically eligible for an MA degree—the arcane Oxford rule dates back to the early nineteenth century, to the befuddled irritation of those from other institutions who have to put in actual *work* to get a master's degree. My degree eligibility was perpetual, and because I lived overseas it was not until the mid-1990s that I was back again at the Sheldonian—my ageing parents in loyal attendance—to receive it. The vice-chancellor of the day welcomed me to the distinguished fraternity of those who could now, and in perpetuity, cast votes for the university's chancellor and professor of poetry, and could become a member of the body known as Convocation. Small gifts indeed, but in the world of Oxford, the kind of gifts that bind, for years to come.

* * *

I mentioned earlier the presence of a small door that is cut into the left side of the rear interior wall of the Museum of Natural History. This is the gateway to one of the more remarkable collections in all the world, the Pitt Rivers Museum of anthropology and world archaeology— half a million items from across the planet, which illustrate mankind's innumerable activities, beliefs, and fears from time immemorial. A Victorian army officer, Augustus Henry Lane Fox Pitt-Rivers organized his personal collection by type, not by age or origin. Then in 1884 he offered his collection to the university, so long as a lecturer in anthropology was appointed and a building was erected to house his gift. Following the general's example, all bagpipes whether from Scotland or from Romania are displayed together; as is all the tattooing equipment, whether from the Maori of New Zealand or from Oxford's Cowley Road; and all the shields, whether used by Kenyan Maasai warriors or by Thames Valley riot police.

There are countless marvels to be seen within. The object I have long revered most in the world is contained inside, housed in a six foot tall box, made of mahogany and glass, and which stands towards the back of the museum. Heavy velvet curtains shield its contents from the fading effects of sunlight; there is a button at the side that allows artificial illumination, carefully timed, to bathe it briefly in a harmless glow.

The object inside is very fragile, very old, and vivid with an almost unbelievable torrent of colour—slashes of bright scarlet and yellow, and scimitar-curves of the richest black. It is a ceremonial cloak from Hawaii, originally made to be worn by a member of the islands' royal family. What makes the few that survive today so memorable and so priceless is that each was hand-stitched from hundreds of thousands of exquisite bird feathers, and yet without a

bird ever dying in the process of manufacture. And for many reasons—its sheer beauty, its incalculable cultural worth, its connection to a part of the world and to a part of history with which my subsequent travels have held me fascinated—*it calls to me still*. Each time I visit the city I go to see it, to make sure it is still in fine condition. That its keepers are looking after it.

For it calls to me much as the Pitt Rivers does. As much as the Museum of Natural History does. As much as all of Oxford does, with its tiny lanes and rivers and meadows and towers and spires and the clocks that chime the midnight hour in that friendliest of friendly disagreement.

In Oxford there are worlds within worlds within worlds, most of them sequestered behind walls that have kept many out, it is true, but which yet shelter within them a kind of learning and scholarship and excellence as well as that 'cultured or privileged lifestyle' spoken of by the *Oxford English Dictionary*, and of which I supposed I could never take part—but of which, to my great good fortune and by the answering of a pair of questions on that cold winter's day half a century ago, I did indeed take part, and of which I am now, happily and unashamedly, a part still, and for the rest of my days.

You may well leave Oxford, as I have. But Oxford, in all its many aspects, never entirely leaves you. The very word, indeed. Oxford! Dear, dear, irreplaceable Oxford. John Keats was right: the finest city in the world!

ACKNOWLEDGEMENTS

Martin Parr, the Bodleian Library, and Oxford University Press would like to thank a number of institutions who kindly allowed access to their events:

All Souls College

Balliol College

Begbroke Science Park

Bodleian Libraries

Brasenose College

Chancellor's Office

Christ Church

Corpus Christi College

Degree Conferrals Office

Department of Engineering Science
(in particular the Thermo-Fluid Laboratory
and the Mobile Robotics Group)

The Faculty of English

Examinations School

Exeter College

Harris Manchester College

Faculty of History

Jesus College

Keble College

Kellogg College

Lady Margaret Hall

Lincoln College

The Oxford Tolkien Society (Taruithorn)

Oxford Union

Oxford University Athletic Club

Oxford University Museum of Natural History

Oxford University Press

Oxford University Rugby FC

Oxford University Student Union

Oxford University Tolkien Society

Oxford University Welsh Society

Pembroke College

Proctors Office

Regent's Park College

Ruskin School of Art

School of Geography and the Environment

Somerville College

St Michael in the Northgate

St Benet's Hall

St Hilda's College

St Hugh's College

St John's College

St Stephen's House

St Edmund's Hall

Trinity College

The University Bedels

University Church of St Mary the Virgin

University of Oxford Events Office

Vice-Chancellor's Office

Wadham College

Wolfson College

Zoology Department

A number of individuals offered their particular support: Professor Andrew Hamilton and Professor Louise Richardson, successive vice-chancellors; Simon Armitage, Professor of Poetry; Jenni Smith; Louis Little; Tom Groves; Matt Cotton; Rosemary Rey; and Suzanne de la Rosa.

Finally, a special thank you to Rosie Burke, Richard Ovenden, and Sophie Goldsworthy, without each of whom this project could not have happened.

OXFORD
UNIVERSITY PRESS

Great Clarendon Street, Oxford, OX2 6DP,
United Kingdom

Oxford University Press is a department of the University of Oxford.
It furthers the University's objective of excellence in research, scholarship,
and education by publishing worldwide. Oxford is a registered trade mark of
Oxford University Press in the UK and in certain other countries

Published in the United States of America by Oxford University Press
198 Madison Avenue, New York, NY 10016, United States of America

British Library Cataloguing in Publication Data
Data available

Library of Congress Control Number: 2017933156

ISBN 978–0–19–872441–4

Printed in Italy by L.E.G.O. S.p.A.

All photographs were taken between 2013 and 2016.